IMAGES
of America

EARLY LOS ALTOS
AND LOS ALTOS HILLS

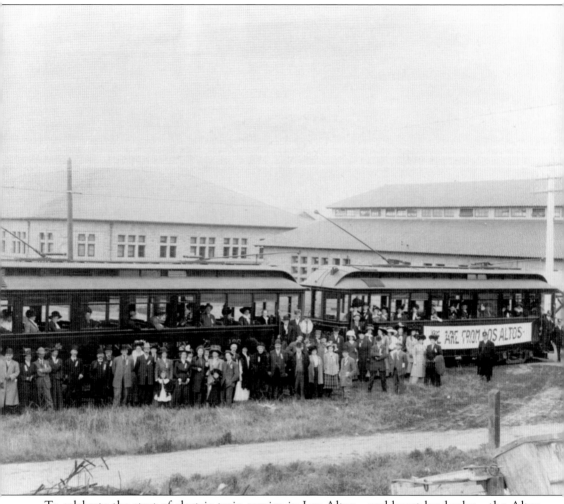

To celebrate the start of electric train service in Los Altos—and boost land sales—the Altos Land Company arranged a free excursion on March 5, 1910. From the town's temporary railroad station, Peninsular Railway's two trolleys took 88 excursionists to Mayfield and Palo Alto, where an informal luncheon was served. The cars then went to Stanford University, where this photograph was taken. A *San Jose Mercury* article reported that "the advent of the cars was cheered by all the towns passed through, and from all the farmhouses along the route greetings were exchanged by the waving of handkerchiefs and hats."

IMAGES
of America

EARLY LOS ALTOS
AND LOS ALTOS HILLS

Don McDonald and
the Los Altos History Museum

ARCADIA
PUBLISHING

Published by Arcadia Publishing
Charleston, South Carolina

Printed in the United States of America

Library of Congress Control Number: 2009934867

For all general information contact Arcadia Publishing at:
Telephone 843-853-2070
Fax 843-853-0044
E-mail sales@arcadiapublishing.com
For customer service and orders:
Toll-Free 1-888-313-2665

Visit us on the Internet at www.arcadiapublishing.com

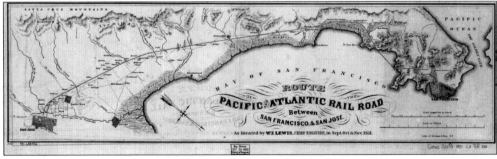

This 1851 map shows the earliest planned railroad route between San Francisco and San Jose. Nearly the same route was eventually completed in 1864, mostly following the traditional Spanish El Camino Real. Many names shown along the route appear to be those of residents. Recognizable settlements shown that still exist include the ports of Ravenswood and Alviso. McCartysville became Saratoga, and Mezesville became part of Redwood City. (Library of Congress.)

CONTENTS

ACKNOWLEDGMENTS

The extensive collection of the Los Altos History Museum was the basic source of information for most of this book. Collections manager Lisa Robinson was effectively its cocreator, doing the heavy lifting in finding and scanning hundreds of appropriate images and, where necessary, securing publication rights. Executive director Laura Bajuk and Jane Reed, in charge of the museum's exhibitions and collections, gave me valuable guidance and advice. Jim Thurber, Kathy Lera, Judy Dahl, and Judie Suelzle were extremely helpful in the final reviews, as was staff member Aimee McKee. Our historical colleagues provided additional materials: John and Lana Ralston of the Los Altos Hills Historical Society, Esther Mort from Pilgrim Haven, and Barbara Kinchen and Honor Spitz of the Mountain View History Center were unfailingly cooperative. Mary Jo Ignoffo, author of a new book about Sarah Winchester, shared fresh information about the Winchester-Merriman ranch.

Books and pamphlets consulted were *Los Altos Hills: The Colorful Story* by Florence M. Fava; *Memories of Los Altos* by Joe Salameda; *Los Altos: Portrait of a Community*, edited by Paul Nyberg; *The Birth of a Town*, compiled by Edwin B. Woodworth; and *Los Altos Reminiscences*, compiled by the California History Center. The *Los Altos Town Crier* newspaper and its special publications provided essential information. Other contemporary newspapers and periodicals consulted were the *Mountain View Register-Leader*, *Oakland Tribune*, *Palo Alto Times*, *San Jose Mercury*, and *The Ferroequinologist* of the Central Coast Chapter, National Railway Historical Society.

—Don McDonald
historian

History is an ever-changing work of detection and interpretation, piecing fragments together that often state competing information for the same occurrence. Despite feeling that it is a never-ending task full of surprises and new information, we at the Los Altos History Museum have paused for a moment to commit to this volume. We lost sleep, knowing that, despite our best efforts to check every detail, consult primary sources, and question popular knowledge, we missed something. We mourn the great photographs that outnumbered the available space and those that simply weren't obtainable. (Additions to the archives are welcome!) Unless otherwise noted, all images appear courtesy of the Los Altos History Museum and are copyright 2010. We hope you enjoy this volume, and while we tenderly await your response to this group effort, we dare to consider another such venture to document the chapters of history that follow those enclosed. Thank you for your interest in our history—we hope you enjoy the book.

—Laura Bajuk
executive director, Los Altos History Museum

INTRODUCTION

This book tells through images and captions the first 100 years of the American history of the area that became the towns of Los Altos and Los Altos Hills. The story begins in the 1850s, following the California Gold Rush and statehood. This change of sovereignty automatically made it necessary to decide who had legal claim under U.S. law to the former Mexican rancho lands. For this, a U.S. land commission was formed to consider the evidence and issue official patents to the owners. The commission's work was complicated and lengthy for various reasons; rancho boundaries were vague, with hand-drawn maps (*diseños*) often showing only creeks and trees. Mexican grantees had often sold parts or all of their land, sometimes because of the delays and costs of litigating the land's title. Some rancho land was overridden by patents granted to railroads. And, at times, there were settled squatters to be considered.

The original diseño for Rancho San Antonio showed all of the land between Adobe and Permanente Creeks, but because of complications like those just mentioned, its patent was only for land southwest of what became today's Foothill Expressway. Most of the land that eventually became Los Altos was declared "government land," and from it many of the patents issued were to developers. But neighboring Rancho La Purissima Concepcion did not experience the same title problems as Rancho San Antonio, and its patent covered virtually all of what became Los Altos Hills.

Some large, self-contained ranches, chiefly growing wheat and cattle, were built on patent land. Developers bought this land knowing that rail service begun in 1864 would open up the route between San Francisco and San Jose. Passengers could travel quickly between these two cities, effectively turning some peninsula communities into suburbs. New reliable and fast freight service meant that large ranch lands could be profitably divided into smaller plots suitable for growing more perishable crops of much higher value. This led to a mighty profusion of fruit and nut orchards, which with their clouds of springtime blossoms eventually made Santa Clara County world famous as the "Valley of Heart's Delight."

The new railroads also led directly to the establishment of Los Altos. Southern Pacific Railroad decided in 1904—when one of its subsidiaries was expanding electric trolley service on the peninsula—to build a new line between Mayfield (later south Palo Alto) to link to its San Jose and Los Gatos Interurban line. This new route skirted the sparsely settled easterly foothills of the Santa Cruz Mountains. About midway, it passed through land owned by Sarah Winchester, and there, the railroad ran into a problem. Winchester flatly refused to grant them a right-of-way because it would destroy the integrity of the ranch, run by her sister Isabelle and her husband, Louis Merriman. After some months of negotiations, Sarah finally relented but on the condition that the railroad would buy the entire ranch—about 140 more acres than they needed.

At this point, Paul Shoup, a Southern Pacific executive, and Walter Clark, a Mountain View real estate developer, saw the potential of the Winchester-Merriman acreage as a new town site. Not only was it at a logical stopping point on the new railroad route, but it was conveniently bordered by Fremont, Moody, and San Antonio Roads. Shoup and Clark formed the Altos Land Company, raised the necessary money, and after overcoming various problems and delays

bought the ranch plus some additional land. They filed the official plat for Los Altos in 1907. The name Los Altos, meaning "the heights" or "foothills" in Spanish, had been used in Mexican years as an informal description of the relatively high lands of Ranchos San Antonio and La Purissima Concepcion.

Los Altos failed to grow as quickly as its developers had hoped, but it gradually attracted enough business and families in its first decades to spread its practical influence into county land well beyond its legal limits. These unofficial boundaries were defined differently by the school board, post office, and public utilities. Some of this "greater Los Altos," in the El Camino Real corridor in what later became north Los Altos, attracted Stanford professors and wealthy San Franciscans who built lovely estates for their retirement or as second homes to escape summer fogs. The convenience of the railroad attracted others to build along its line south into the Loyola Corners area. Geographically, the largest and least populated part of this "greater Los Altos" extended up into the hills via Miranda, Fremont, and Moody Roads, and there, builders of large and elaborate estates included San Francisco mayor "Sunny Jim" Rolph and San Jose's Louis Oneal. From the 1930 census, it appears approximately 2,900 people would have considered Los Altos to be their home.

Perhaps because it was still largely agricultural, Los Altos was marginally less affected by the Great Depression than most American towns were. One of its casualties was the Peninsular Railway (formerly Interurban Electric Railway) in 1933. Its patronage had peaked in 1915 and was steadily declining as automobiles became more prevalent.

In 1942, Los Altos worked to do its part during World War II. Many local women and older men worked in nearby war industries. Hospitality was warmly extended to soldiers and sailors at nearby military bases. The town consistently met its assigned goals for various drives to sell war bonds and collect basics like metal needed for the war effort. Some 400 local men served in the armed forces; 30 of them failed to survive. Some citizens—the nearly 350 of Japanese heritage—were interned at Heart Mountain, Wyoming. Ironically, some of their young men fought in the U.S. Army with great distinction.

After the war, Los Altos went through the same amazing postwar population boom experienced by other peninsula towns. Its historical orchards were gradually replaced by housing developments, and new schools were built in a hurry as young families poured into the area. By the end of 1949, thoughtful residents saw an uncertain future for their "greater Los Altos." Not only was there a constant threat of being annexed by Palo Alto or Mountain View, but many owners were dissatisfied with Santa Clara County's services and zoning policies. As a result, talks were already underway, which in a few years would result in elections making Los Altos and Los Altos Hills incorporated independently.

In an unfortunate irony, the Southern Pacific Railroad, so important to the birth of Los Altos, could not share in its new prosperity. Like its electric subsidiary had earlier, it was fighting a losing battle with automobiles. Although it continued one-train-a-day service to and from San Francisco, it finally stopped service in the early 1960s.

Our story covers this first American century before incorporation, from about 1850 to about 1950.

One

BEFORE LOS ALTOS APPEARED

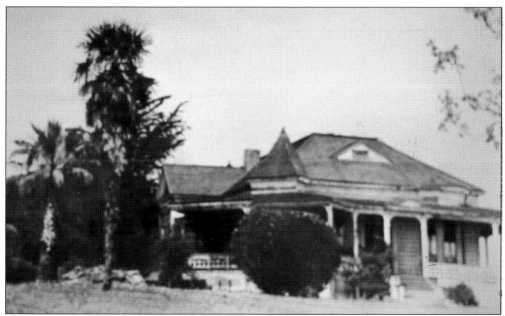

When she married William P. Taaffe, Elizabeth Murphy was given 2,800 acres (roughly equal today to half of Los Altos Hills) as a wedding gift by her father. Martin Murphy Sr.'s party had arrived in central California in 1844. Already wealthy, he became a successful rancher, eventually having vast holdings south of San Jose. His son Martin Jr. became even wealthier, with land from San Francisco to Santa Barbara County. This photograph shows the original Taaffe house. Many Taaffe descendants still live in the area.

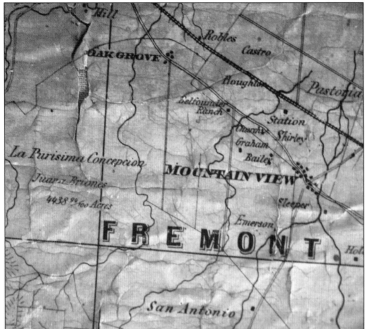

Oak Grove is shown at the top of this detail of Healey's 1866 map, at the intersection of El Camino Real (the double line) and San Antonio Road (the single line heading south). Its 34 acres may have been the earliest farm in what is now Los Altos. It was named by its first owner, Capt. William W. Brown, whose farmhouse featured a mahogany balustrade, carved teak staircase, and household fixtures he brought around the Horn from Boston.

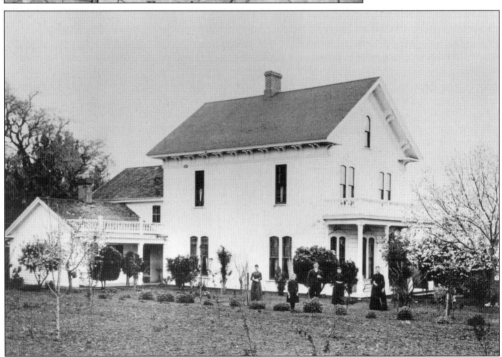

The Snyder family is shown here in front of their ranch home, one of those celebrated in the 1876 Santa Clara County atlas. John Snyder arrived here as a forty-niner and by 1861 had acquired 1,160 acres between Permanente and Stevens Creeks. Some of it became Hillside Farm, whose lucrative first crop of grain proved dry-land farming was practical in the area. Later it became divided into open space district areas, St. Joseph's College, Maryknoll Seminary, the Forum retirement community, and home subdivisions.

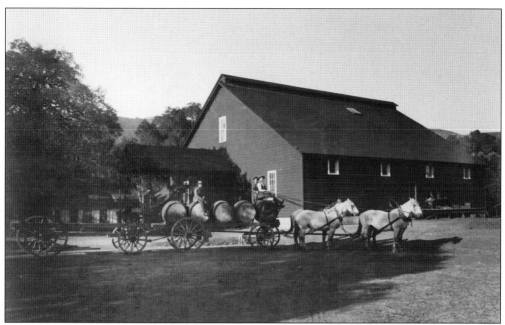

This is a photograph of Snyder's wine casks on their way to market. Until phylloxera devastated the vines in the late years of the 19th century, wine was a prominent export from the Santa Clara Valley. In 1896, there were 22 wineries in the greater Mountain View area alone.

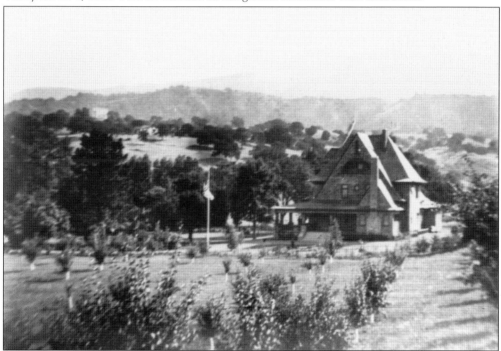

Willard Griffin moved to this area in the 1880s and bought 98 acres on Moody Road. The shingled Craftsman house shown here was designed by the same architectural firm that designed the Paul Shoup house on University Avenue. Most of what Griffin termed his Lakewood Estate eventually became Foothill College, where the house still stands.

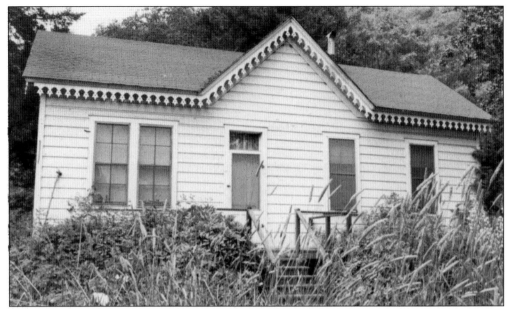

Bought by Otto Arnold in 1888, this 750-acre ranch on Moody Road about 5 miles south of Fremont Road was said to have been a stop on the stagecoach route to Pescadero, then a thriving seaside community. The ranch included a farmhouse (shown here), horse corral, large barn, blacksmith shop, and other outbuildings. In 1924, the by-then 1,000-acre ranch, Hidden Villa, was bought by Frank and Josephine Duveneck.

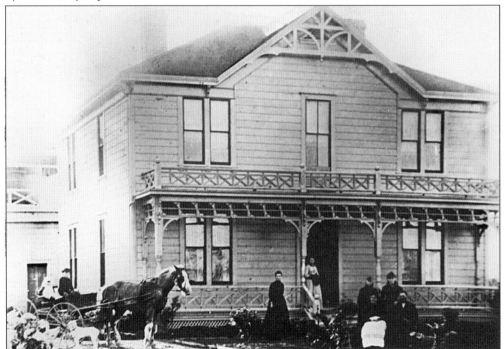

The Kifer family farmhouse on Grant Road (between Fremont Avenue and Foothill Expressway) was built in 1888. Its 2½-holer "vintage comfort station" (outhouse) is now installed at the Los Altos History Museum.

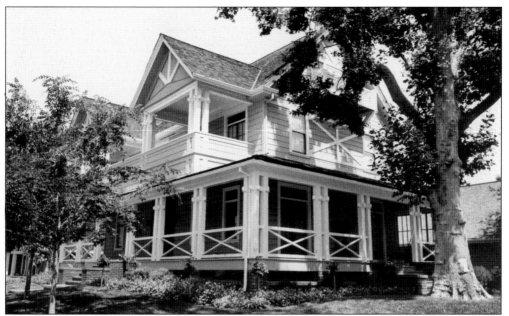

In 1891, David Farnsworth bought 15 acres "out in the country" along El Monte Road. The lovely home and adjacent barn he built there still exist, with rows of palm trees framing the road leading to the entrance. His two iron gates had handles forged with interlocking letter Fs and the date 1895 below. The balcony built across the front reflects the then-current thinking that sleeping outdoors helped prevent tuberculosis.

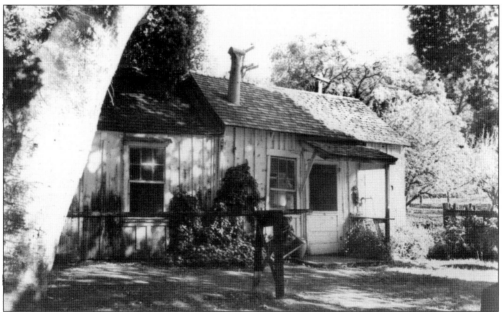

This is the original shack built in 1864 by homesteaders T. F. and G. H. Grant on their ranch, which included what is today Deer Hollow Farm. Grant Road was named for the brothers, and part of it later became St. Joseph Avenue. There is a story that George killed a grizzly bear on their property, which, if true, meant grizzlies existed here after 1850, the date commonly given for their local eradication.

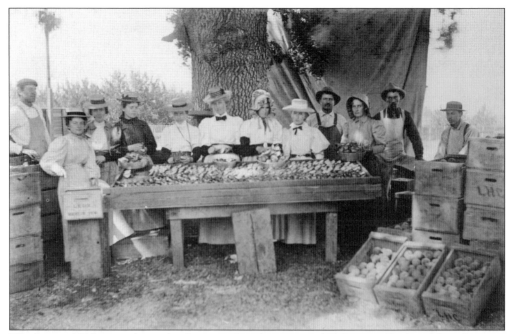

This happy 1896 scene shows the fruit stand at the corner of El Camino Real and San Antonio Road. Box initials indicate that the fruit being sold was from one of Mountain View's early orchardists, L. H. Case.

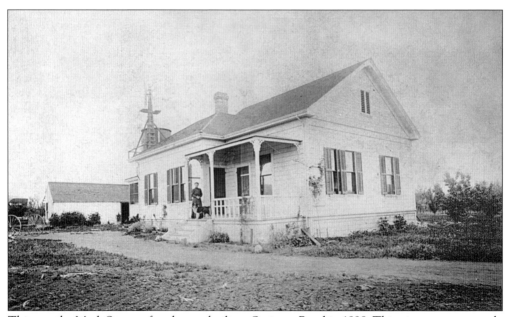

This was the Mark Stevens farmhouse, built on Springer Road in 1898. This view was apparently taken looking west.

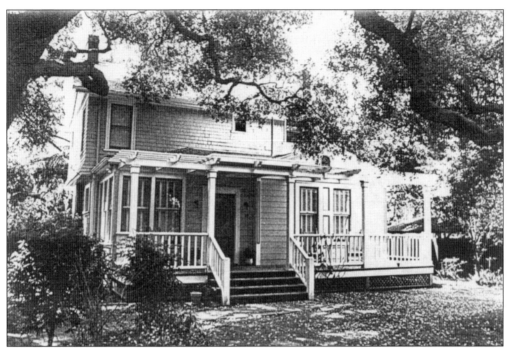

The farmhouse pictured here was built in 1898 on San Antonio Road (then called Giffin Road), south of El Camino Real. Edward and Emma Carothers bought the established 15-acre orchard in 1905. Two years later, they formed the Music and Literary Club with 56 charter members who shared their cultural interests. The club's monthly programs featured dramatic readings, musical selections, and talks. It also hosted parties and dances. In 1908, the Music and Literary Club changed its name to the San Antonio Country Club after moving into a new clubhouse across San Antonio Road, its name being officially changed from Giffin Road the same year.

Dedicated to improving their neighborhood community, the San Antonio Country Club took on civic interests, petitioning the county for such things as bringing in electricity and improving Giffin Road by watering summer dust and spreading gravel on winter mud. The new clubhouse was built on land donated by Margaret Hill's mother, Julia Chandler Hill. During its 100 years of existence, the building has been used for various entertainments, civic functions, schools, and volunteer organizations.

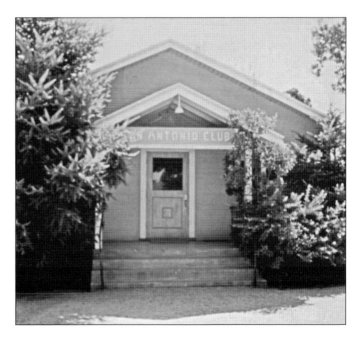

This may have been the view from the hills along Magdalena Avenue when Prof. John Montgomery conducted some of his pioneering glider flights here in 1904. John was normally accompanied by his brother James. They stayed with their friends the McKenzie family, whose large orchard was located nearby across Fremont Avenue.

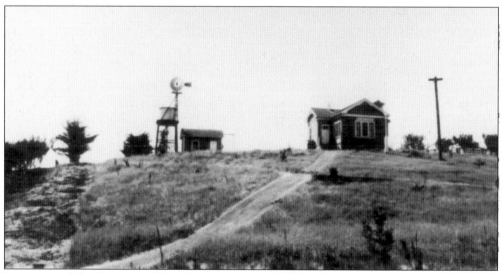

Formation of the Purissima School District in 1901 followed increased settlement of the 1897 subdivision of the William F. Taaffe lands. The first school is shown above with cloakroom/toilet and water tank. It was built on 2 acres bought by the district near the intersection of Robleda and Purissima Roads. This was the only grammar school in the area until the town of Los Altos established a makeshift school in 1908 and its own school district in 1911.

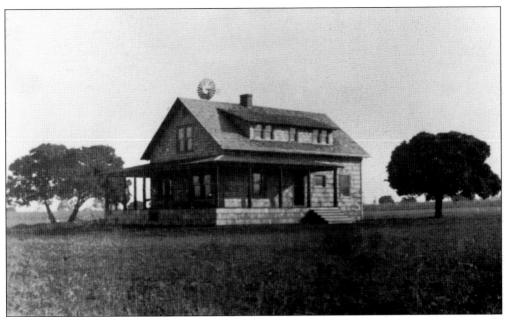

In 1901, J. Gilbert Smith bought 5 acres along Giffin (later San Antonio) Road, then a dirt road linking El Camino Real with Fremont Avenue. He personally built his redwood farmhouse and planted an orchard of Blenheim apricots. A skillful carpenter, Smith was proud that "not a shingle loosened" on his farmhouse during the 1906 earthquake—but his windmill collapsed with its water tank. When he could, Smith worked part-time as a builder and contractor.

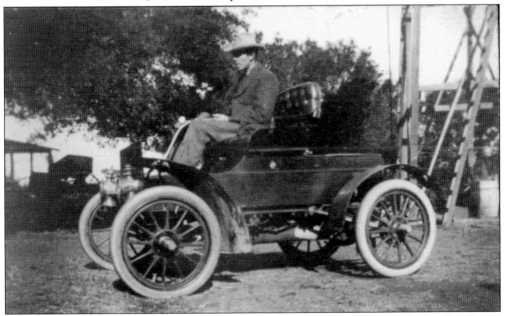

When Gilbert Smith finished building his farmhouse in 1905, his mother, Mary Shane Smith, and sister Elinor moved in, naming it The Oaks. He is shown here at the tiller of his 1905 curved-dash runabout Oldsmobile, possibly the earliest auto in the area. When Mary died in 1931, Gilbert married Margaret Hill, a childhood friend. After they died, their farmhouse was renovated for public use and opened in 1977 as the Los Altos History House Museum.

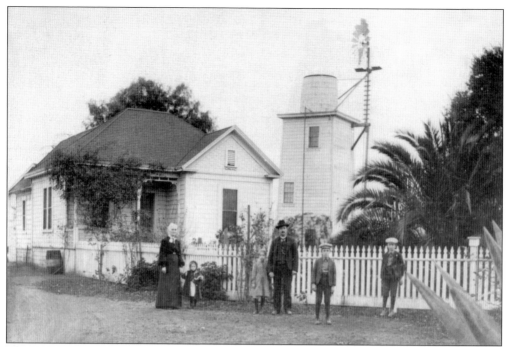

The Fritts family bought this farm on El Monte Road in 1892. Pictured here in 1906 are, from left to right, Laura Goodall Fritts (Martha's great-aunt), Martha, Grace, Joseph, William, and Joseph Jr.

Mr. and Mrs. Marvin O. Adams bought 30 acres in 1906 on San Antonio (Giffin) Road south of Gilbert Smith's orchard. This photograph shows prunes drying in front of their tank house. The Colonial Revival–style house they built still exists, and its driveway—lined with pepper trees—became today's Pepper Drive.

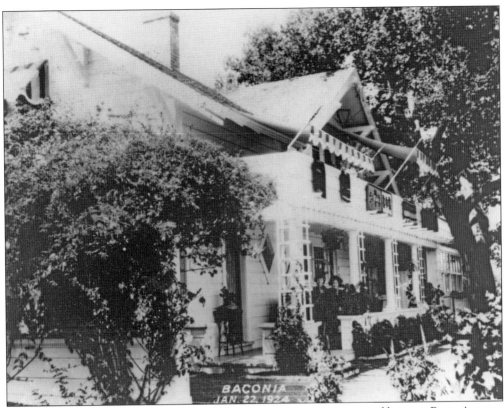

This photograph is of Baconia, the Frank Bacon family home, a converted barn on Berry Avenue. Bacon was a well-known thespian at the end of the 19th century, touring the country with his "All Star Cast." Performing in San Francisco at the time of the 1906 quake, he walked home to Los Altos, which took two days.

This 1903 photograph shows the Menzo Loucks family in front of their old farmhouse, shortly after they bought it from Captain Brown's widow, Mercy Sherman Brown. A professional horse-breaker, Loucks shipped wild mustangs from Oregon. He would drive them from the Mayfield (now south Palo Alto) station down El Camino Real to his ranch for breaking and training. He also raised cash crops of grain, apricots, and prunes on his 34 acres.

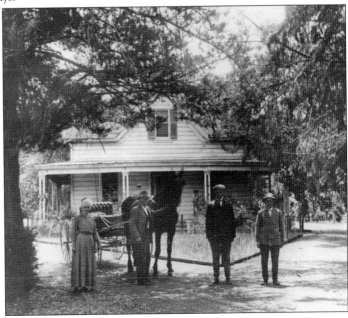

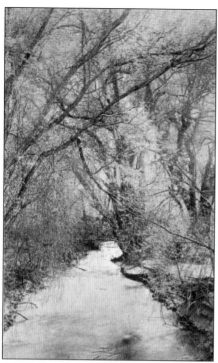

Population increases along the San Francisco Peninsula impinged on local creeks, which fed underground water into the many new wells. Sometimes creeks were also diverted for irrigation purposes, and lawsuits are recorded asking for injunctions against this action. One such lawsuit claimed that along Adobe Creek, shown here, diversions "left it dry certain seasons of the year," confirming accounts that a year-round flow of water was normal in those early years.

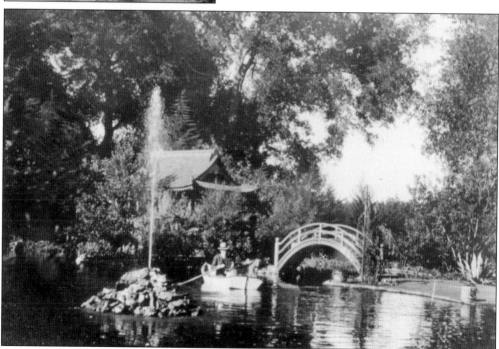

Adobe Creek was diverted on the Griffin estate to make an aquatic garden in the Japanese style, as pictured here. Creeks were used for fishing, and John McKenzie recalled fishing on Permanente Creek when he was a lad (about 1902), using a kernel of corn for bait. Creeks were also dammed to make a small lake for irrigation, as on McKenzie's land, and for swimming holes, as on the Costello and Halsey lands along Adobe Creek.

Two

THE SOUTHERN
PACIFIC RAILROAD
MIDWIFE

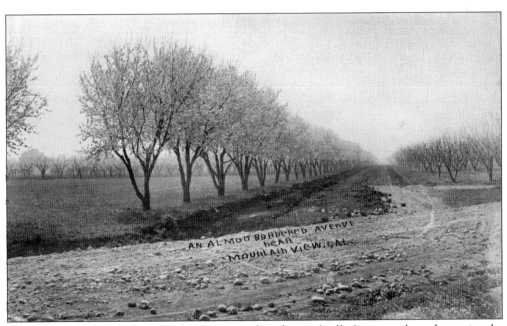

AN ALMOD BORDERED AVENUE
NEAR
MOUNTAIN VIEW, CAL.

The Southern Pacific Railroad wanted to expand its electric (trolley) service along the peninsula, much of which was orchard land as in this 1910 photograph. To do this, it bought the San Jose–Los Gatos Interurban Railway in 1904 as its southern base. This new Interurban Electric Railway (later the Peninsular Railway) had as its dynamic president Oliver A. Hale, who announced plans for his line to join San Jose and Palo Alto. Anxious to begin, he deployed surveyors—before securing all rights-of-way—including across Sarah Winchester's Los Altos ranch land.

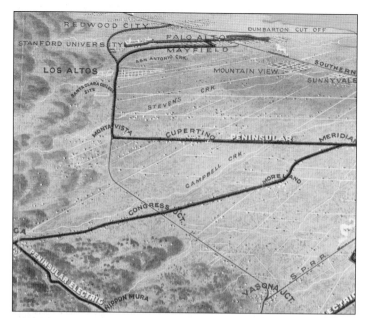

Oliver A. Hale planned the new electric railroad route (the Mayfield–Los Gatos Cut-off) to join Palo Alto with San Jose as shown on this map. When its route followed existing county roads, no new right-of-way was needed, as along the north boundary line of Rancho San Antonio. But beyond that, its route cut directly across Sarah Winchester's land, where Hale belatedly found he needed to procure a right-of-way.

Sarah Winchester bought 165 acres in 1888, and after remodeling the existing farmhouse, she turned the ranch over to her sister Isabelle and her husband, Lewis Merriman. Naming it El Sueño ("The Daydream"), they raised carriage horses and their own food and wine. They also enjoyed active social lives, but their halcyon existence was rudely shattered in 1904 when railroad surveyors appeared. The Merrimans resisted, pulling up surveying stakes at night. Winchester was also furious, but a year later, she agreed to sell—if the railroad would buy the entire ranch—since the proposed right-of-way would destroy the ranch's integrity.

Paul Shoup, shown here with his son Carl about 1907, had an amazing career with the Southern Pacific (SP). With a high school education, he rose from ticket agent for the railroad in 1891 to president of the Southern Pacific Company in 1929 through extraordinary vigor, intelligence, and initiative. In 1904, he learned that an SP subsidiary was planning a new electric railroad (trolley) route between Mayfield and Los Gatos. He saw that this route offered an intriguing real estate opportunity in the form of a new town near its junction with San Antonio, Fremont, and Moody Roads. With Walter A. Clark and other friends, he brought this dream to reality and established the new town of Los Altos in 1907. Paul Shoup was transferred to Los Angeles in 1913, and although it was never again his full-time residence, he is generally recognized as the "Father of Los Altos" because of his seminal role in its establishment.

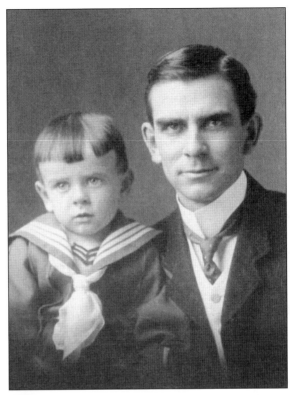

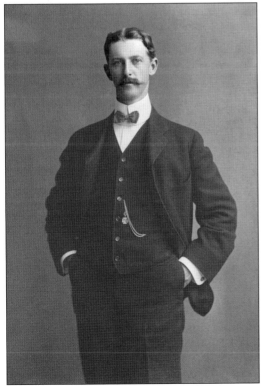

Walter A. Clark arrived in Mountain View in 1886 and formed a successful real estate business. He was soon active in civic affairs, among other things serving as a member of the state assembly. He became friends with Paul Shoup, serving with him on the Central Coast Counties Improvement Society. Clark was intimately familiar with all of the land through which the new railroad route would pass, and he doubtlessly recognized the largely undeveloped Winchester-Merriman ranch to be an ideal spot for a new town. (Mountain View History Center.)

INTERURBAN ROAD PURCHASES TRACT

Buys 100 Acres Between Here and Mountain View on the Route of Proposed Road.

The Interurban Electrical Railroad Company has purchased a 100-acre tract from Mrs. S. L. Winchester, between here and Mountain View on the route of the proposed electric road. This tract is intended for a town site and has been given by the purchasers the picturesque name "Banks and Braes."

An August 1906 press article reported (prematurely and inaccurately) that the Interurban Electric Railway had bought 100 acres from Sarah Winchester for a new town to be named "Banks and Braes." Today this seems to be an odd name for a town, but it was familiar then as a popular song based on a Robert Burns poem. In the end, the name was changed back to the regional designation for the two Spanish ranchos, San Antonio and La Purissima Concepcion. After Winchester deeded her land to it, the Altos Land Company formed by Shoup and Clark filed the official plat for "Los Altos" in June 1907.

San Francisco, Cal., April 16, 1908.

Mr. W. S. Clayton,

President First National Bank,

San Jose, Cal.

Dear Sir:—

As you know, the University Land Co. owes Mrs. Winchester $20,000 on its property in Los Altos townsite. Mr. Clark called on Judge S. F. Leib last Monday to see what arrangements could be made to release lots on payment of value, give deeds and also make part payments on the debt as a whole. Unfortunately, as you no doubt know, any extra business cares cannot be undertaken by Mrs. Winchester at this time, and Judge Leib advised Mr. Clark accordingly.

Because the railroad only wanted a small section of the Winchester-Merriman ranch, Shoup and Clark formed the University Land Company with a group of investors to buy the rest of the ranch. With interlocking directorates, they formed other companies to deal with water, financing, and other details involved in developing a new town. As this 1908 letter shows, they had some early difficulty paying Winchester. Judge S. F. Leib was Winchester's attorney and was on the board of the Interurban Electric Railway.

A *Los Altos Star* article described plans to install an electric line within Los Altos to connect with Mountain View. After encircling Main and State Streets, it was to connect with the line heading to Loyola Corners. From there, a *Mountain View Register Leader* article reported it would connect with a new line to Mountain View's Castro Street station, a line illustrated in this page, at right, from Walter Clark's 1909 brochure. The line was never built.

Laying a new railroad bed through open country was a laborious process in those years. Grading involved horses and mules hauling "Fresno Scrapers" and steam shovels, plus human pick and shovel power. In the Los Altos area, six creeks needed bridging. After ties and tracks were laid, gondolas brought in ballast to secure them. San Francisco's 1906 rubble was included in local ballast, and sometimes inquisitive children found artifacts from that disaster, in one instance a key to a room at the Palace Hotel.

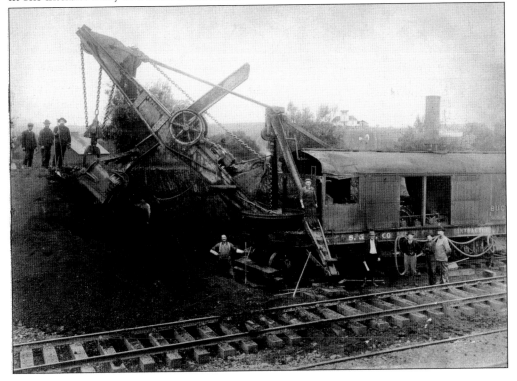

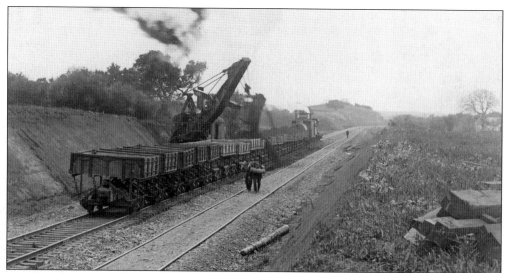

This image shows work finally underway for the Mayfield–Los Gatos Cut-off in 1907. There had been serious delays. In 1905, the Colorado River breached a diversion dam, letting a great flood of water pour into Imperial County lowland, forming the Salton Sea. This wiped out farmers and the main Southern Pacific rail line to the East Coast. Paul Shoup was sent to confront this emergency; he promptly diverted rails Hale had stockpiled at Congress Junction for his new cut-off. In 1906, the Southern Pacific again called on Paul Shoup to supervise emergency reconstruction work after the San Francisco earthquake and fire. And the nationwide Banker's Panic of 1907 may also have affected the company's finances adversely, contributing to more construction delays.

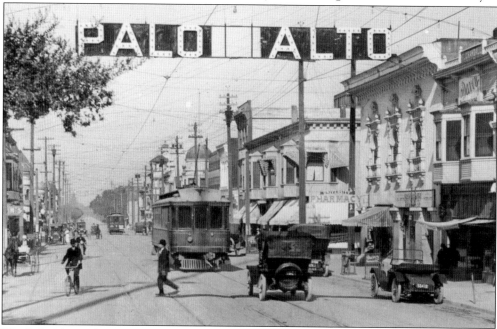

The Palo Alto and Suburban Railway Company's trolley line began service in 1906. Three years later, the line was extended to a Stanford University terminus at University Press corner. The line was bought by Southern Pacific and connected to their California Street terminus of the Mayfield–Los Gatos Cut-off. (Mayfield was annexed by Palo Alto in 1925.)

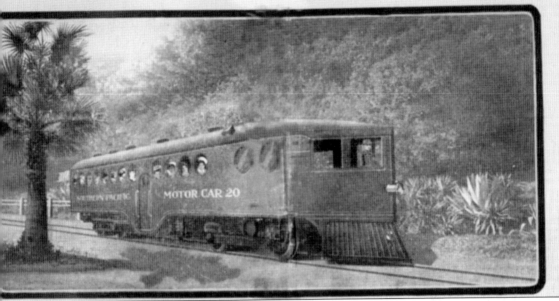

The *Los Altos Star* printed this prospectus for the beginning of train service in October 1908, using new state-of-the-art gasoline-engine McKeen cars. By then, Southern Pacific had already begun steam service, despite earlier plans to start the new Mayfield–Los Gatos Cut-off with electric service. This change may have been a way to help solve a freight overload problem on its main San Francisco–San Jose steam line.

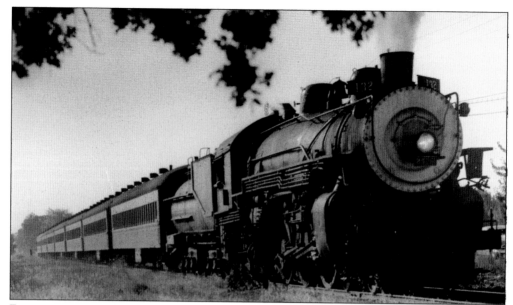

For various reasons, O. A. Hale's earlier plan for an electric railroad through Los Altos was delayed, but Southern Pacific began running steam train service in 1908. Electric service followed in 1910. Southern Pacific No. 2476, pictured here, was one of several purchased by SP in the 1920s and that ran in passenger and freight service until the late 1950s. (Photograph by Fred C. Stoes, Yesteryear Depot Collection.)

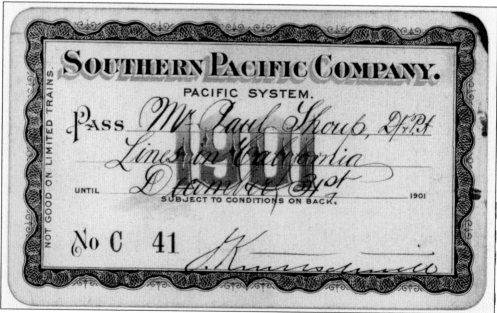

This 1901 pass for Paul Shoup shows Southern Pacific Railroad's typical concern for its employees. The railroad was only part of the SP Company's empire, which in 1904 was among the world's largest corporations. In expanding its railroads, its business tactics were widely portrayed as squeezing out competitors with better and cheaper service if they refused to sell. Some later scholars have seen their actions as usually consistent with the public good and often taken before the government woke up to the need for action.

Three

PROMOTING THE "JEWEL OF THE PENINSULA"

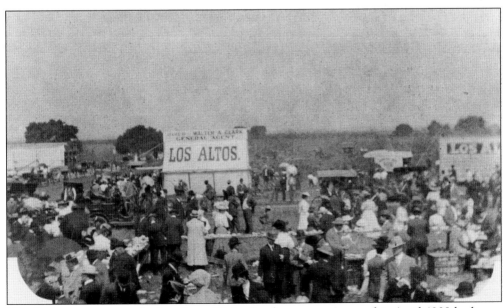

The first major event to begin sales publicity for the new town was this April 1908 barbeque organized by Walter Clark. A steam train brought in prospective buyers from San Francisco the day before the new line was formally opened.

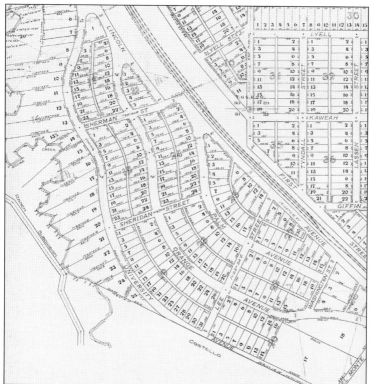

This is the original town plat for Los Altos, filed officially in June 1907. The Civil War was still a vivid memory, perhaps explaining such street names as Lee, Sheridan, Lincoln, and Sherman. University Avenue, with the most expensive lots bordering Adobe Creek, took its name from the fact that Los Altos was located midway between Stanford University and Santa Clara College, the latter planned at Loyola Corners but never built.

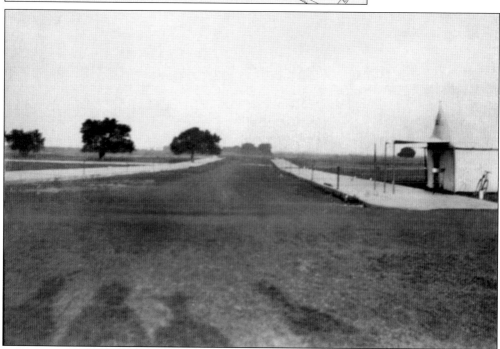

This photograph was taken in 1907, looking north on Main Street, after the streets and sidewalks had been put in. The hitching posts remind one that horses were far more common and reliable than the primitive cars of that period.

This is typical of the advertisements Walter Clark placed to promote the new town. Its promise of a 5¢ fare to Santa Clara College (now Santa Clara University) could not be kept because the college was never built as a result of funds being diverted to reconstruction of the Santa Clara campus after the 1906 earthquake. The promise of sewers was eventually delivered—some 60 years later.

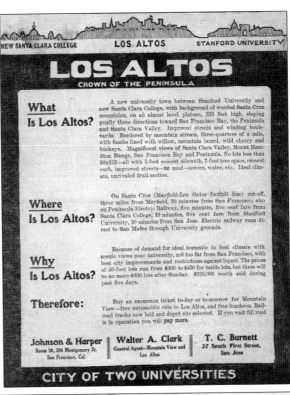

NEW SANTA CLARA COLLEGE LOS ALTOS STANFORD UNIVERSITY

LOS ALTOS
CROWN OF THE PENINSULA

What Is Los Altos?

A new university town between Stanford University and new Santa Clara College, with background of wooded Santa Cruz mountains, on an almost level plateau, 225 feet high, sloping gently three directions toward San Francisco Bay, the Peninsula and Santa Clara Valley. Improved streets and winding boulevards. Bordered by mountain stream, three-quarters of a mile, with banks lined with willow, mountain laurel, wild cherry and buckeye. Magnificent views of Santa Clara Valley, Mount Hamilton Range, San Francisco Bay and Peninsula. No lots less than 50x132—all with 5-foot cement sidewalk, 7-foot tree space, cement curb, improved streets—no mud—sewers, water, etc. Ideal climate, unrivaled fruit section.

Where Is Los Altos?

On Santa Cruz (Mayfield-Los Gatos foothill line) cut-off, three miles from Mayfield, 50 minutes from San Francisco; also on Peninsula Electric Railway, five minutes, five cent fare from Santa Clara College, 10 minutes, five cent fare from Stanford University, 30 minutes from San Jose. Electric railway runs direct to San Mateo through University grounds.

Why Is Los Altos?

Because of demand for ideal homesite in best climate with scenic views near university, not too far from San Francisco, with best city improvements and restrictions against liquor. The prices of 50-foot lots run from $300 to $450 for inside lots, but there will be no more $300 lots after Sunday. $120,000 worth sold during past five days.

Therefore:

Buy an excursion ticket to-day or to-morrow for Mountain View—free automobile ride to Los Altos, and free luncheon. Railroad tracks now laid and depot site selected. If you wait till road is in operation you will **pay more.**

Johnson & Harper
Room 26, 204 Montgomery St.
San Francisco, Cal.

Walter A. Clark
General Agent—Mountain View and
Los Altos

T. C. Burnett
27 South First Street,
San Jose

CITY OF TWO UNIVERSITIES

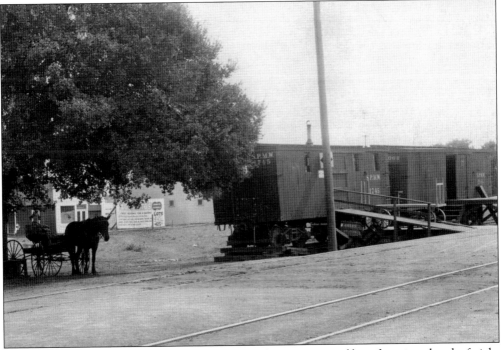

Until a permanent structure could be built, the two boxcars pictured here functioned as the freight and passenger depots for Los Altos. On the billboard behind the oak tree and mule, prices are listed for lots on sale from $400 to $650.

William Eschenbruecher built this—the first house downtown—in 1908 on Second Street. In 1985, it was moved to Los Altos Hills to become its Heritage House.

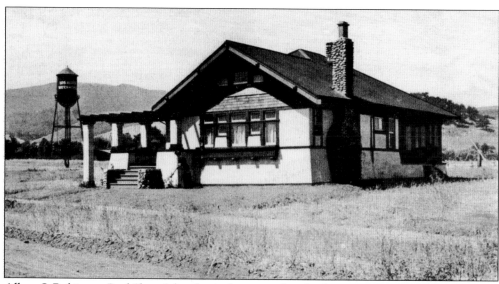

Albert S. Robinson, Paul Shoup's brother-in-law, moved to this house on Orange Avenue in 1909. He became very active in early community life, running the railroad station and first grocery store, among other things. He became secretary of the Altos Land Company in 1913 when Clark left. The 60,000-gallon water tank shown here, beyond the rear of his property, initially furnished water to area residents for $1 a month for 4,000 gallons.

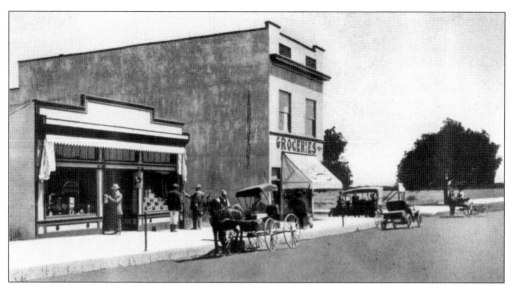

This photograph shows the Eschenbruecher Hardware Store and beyond it the two-story Shoup Building—the first two buildings constructed on Main Street in 1908. The street floor of the Shoup Building was a grocery store, and its upstairs room had multiple usages, as the town's first place for religious services, grammar school classes, Boy Scout meetings, and other civic functions. Both buildings look much the same today and are marked with historical plaques.

In this 1910 photograph, the buggy driver is Clyde "Cy" Taylor, whose apricot orchard was on San Antonio Road near Pine Lane. The newly completed Altos Land Company building can be seen in the background at the corner of Main and First Streets.

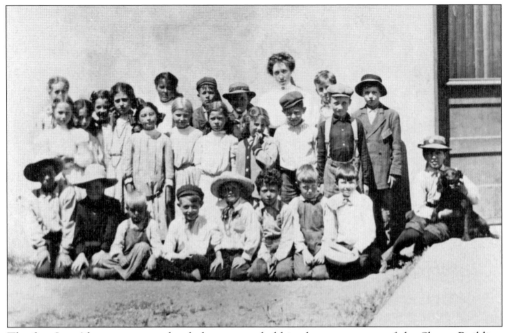

The first Los Altos grammar school classes were held in the upper room of the Shoup Building in 1908. This 1909 photograph shows the entire student body, all taught by the same teacher, Lorena Herbert.

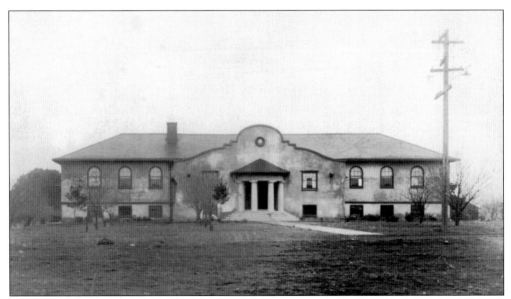

The first school, built in 1911 by the Los Altos School District, was the Los Altos Grammar School. Located on San Antonio Road, just south of Gilbert Smith's orchard, it quickly became a very attractive feature of the area, appealing to parents far beyond the original town boundaries. In effect, it became a factor in the eventual shape of modern Los Altos. Its active PTA was a cohesive force, praised by a city mayor 50 years later as "the glue which kept the community together."

The Copeland Building was the fourth to be constructed on Main Street, on the south corner of First Street. Its two stories housed a drugstore, notions store, soda fountain, candy store, and later the post office. In 1923, it was sold to Jack Gregory, who extended its use for other ventures. In 1927, he transformed part of it into the G&S Theater. The venue featured silent films, and Charlotte Gregory played the organ.

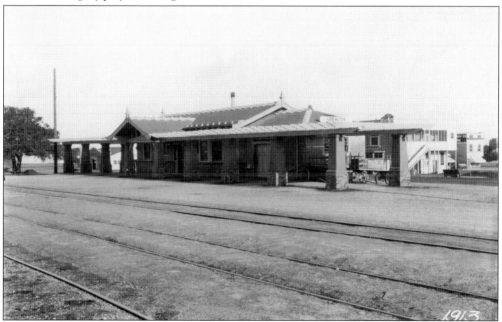

Paul Shoup is credited with wanting Los Altos to have "the finest railroad station on the Peninsula." The result pictured here opened in 1913 and was widely considered an architectural gem. Built by subscription on railroad land, it had cost $12,000 according to the *Mayfield News*—a sizeable sum in those years. After Foothill Expressway replaced the railroad in 1964, the facade of the depot was re-created on the First Street side, and after many business changes, the building is still in use.

The Peninsular Railway built this concrete powerhouse in 1909 to provide electricity needed for the trains, and the side benefit was bringing electricity to the new town. Close by was a compound with a house for the railroad's section boss and cabins for his section hands, who were predominantly Mexican. On the south side of the powerhouse and up an incline from the end of State Street was the freight depot, built in 1911.

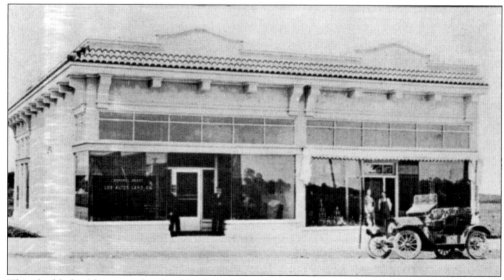

This double building was the third built on Main Street in 1910, at the north corner of First and Main Streets. Part of it housed the Altos Land Company offices, including Walter Clark's. The other part became Gordon's Red and White Grocery Store, which did much of its business on credit and through delivery service. (California History Center, DeAnza College.)

One of Walter Clark's 1909 promotional schemes was to produce this brochure, printed on fine, glossy paper with sharp photographs of Los Altos homes being built "amid the beauty of mountain landscapes." Its attractive color cover showed artistic flair, and Clark's florid text, common for that period, called Los Altos the "Loveliest Place on the Peninsula" and a "Suburb of San Francisco." Only two of the four tracks illustrated were actually constructed.

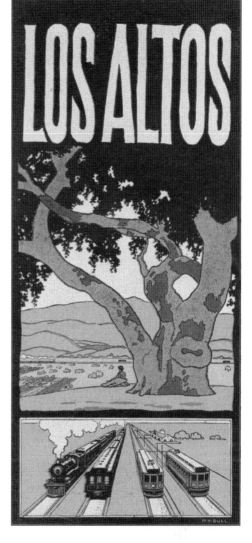

Los Altos looks good "to a man up a tree."

At least one government expert has pronounced the climate of the Los Altos section where the peninsula flares into the valley as ideal and unequaled anywhere; here the mountain airs, the bay breezes and the breath of the valley mingle, the harsher characteristics of each being neutralized. Many a traveler on the trains between San Francisco and San Jose has noticed on cloudy and foggy days the stretch of foothill territory below Mayfield off to the west bathed in sunshine. That may be said to be a Los Altos trademark, for it possesses more days of sunshine than any other peninsula town. Along this foothill a warm air current runs, very noticeable in the evenings and much remarked by strangers coming up from the lower altitudes near the bay. The climate is about as near frostless as any

Inside, Clark's brochure had a touch of humor in this image captioned "Los Altos looks good 'to a man up a tree.'" The brochure also stressed the town's convenience for shopping and commuting because of the steam train and the "soon-to-come" electric train. More hyperbole described Adobe Creek as a "never-failing mountain trout stream—trout caught a few feet from kitchen doors."

Paul Shoup built this house in 1910 on University Avenue. Located on the largest of the prime lots, he specified that part of it adjoining Adobe Creek should become a public park if and when the town was ever incorporated. Shoup helped ensure the attractive ambience of this neighborhood by bringing in his mother, brother, and sister Faith (Mrs. Albert Robinson), plus other friends and colleagues who could afford to live in the most expensive part of the new town. Lots elsewhere were advertised for $400–600, but prices were not given for the large lots along both sides of Adobe Creek.

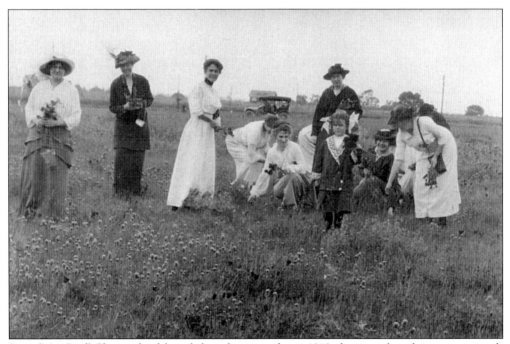

Rose (Mrs. Paul) Shoup, third from left, is shown in this c. 1912 photograph picking poppies with friends in the fields across from their homes on University Avenue.

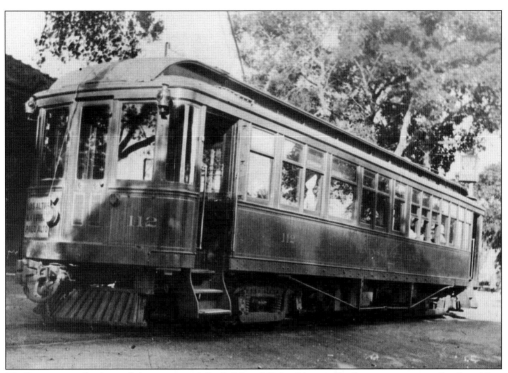

Trolley service facilitated shopping in Mayfield and Palo Alto, and advertisements in the *Los Altos News* reflected this. A far larger number of its advertisements were from stores in these towns than from stores in Mountain View, which was just as close geographically but not accessible by trolley.

Poppy Day at Los Altos

Next Sunday, April 10th, will be "Poppy Day" at Los Altos. Hundreds of acres of the golden California poppies make Los Altos at this particular time of year the most beautiful spot on the Peninsula. Come—bring your family and your friends—bring your lunch and picnic under the oaks or along the banks of the wooded creek—at least come and stay long enough to see this thrifty progressive little city that is to become the Pasadena of northern California. Its winding streets, its sidewalks, its pretty buildings and its perfectly charming location will surely appeal to you—come and pick some poppies anyway. A special excursion rate of one and one-third fare for the round trip will be given from all points on the electric line. There are to be no ceremonies but just a quiet happy day among the poppies. Tell your friends of "Poppy Day" at Los Altos.

ALTOS LAND COMPANY
Los Altos

WALTER A. CLARK, General Agent

Lush stands of poppies and lupine greeted early Los Altos settlers in the open, oak-dotted fields, and Clark used this attractive feature in a 1910 promotion, mailing out this postcard. His "Poppy Day" was celebrated again in several subsequent years.

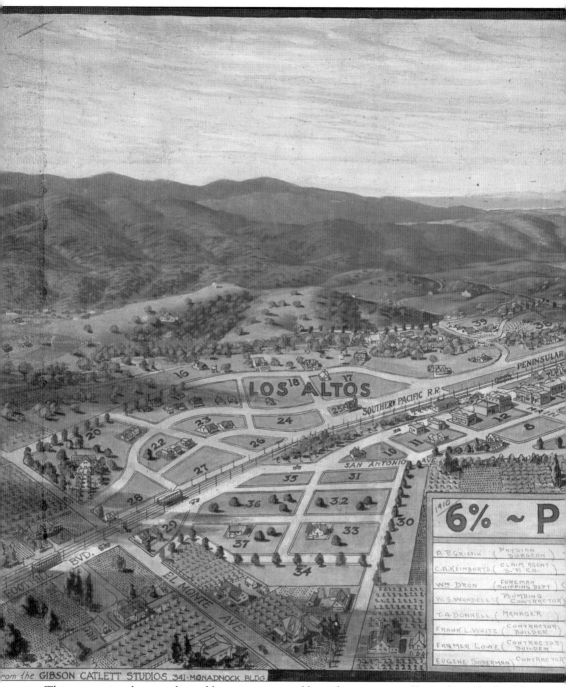

This promotional poster showed lot prices, stressed how the town was effectively a suburb of San Francisco, and boasted the fact that Los Altos was between Stanford University and the expected (but never built) Santa Clara College. When the Jesuits were unable to build the latter, they sold

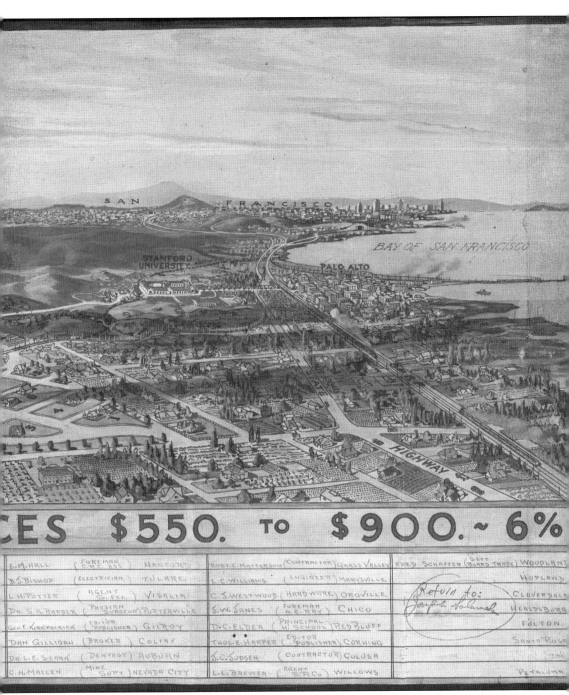

CES $550. TO $900. ~ 6%

E.M.HALL	(FOREMAN C.R.C. ASS)	HANFORD	ROBT.L.MATTERSON	(CONTRACTOR)	GRASS VALLEY	FRED SCHAFFER	(SECT. BOARD TRADE)	WOODLAND	
B.J.BISHOP	(ELECTRICIAN)	TULARE	L.C.WILLIAMS	(ENGINEER)	MARYSVILLE			HOPLAND	
L.H.POTTER	(AGENT S. FEE)	VISALIA	C.S.WESTWOOD	(HARDWARE)	OROVILLE	Return to:		CLOVERDALE	
Dr. S.A.BARBER	(PHYSICIAN SURGEON)	PORTERVILLE	S.W.JANES	(FOREMAN N.E.RRY)	CHICO	Joseph Polaned		HEALDSBURG	
Geo.E.KIRKPATRICK	(EDITOR PUBLISHER)	GILROY	D.C.ELDER	(PRINCIPAL H.SCHOOL)	RED BLUFF			FULTON	
DAN GILLIGAN	(BROKER)	COLFAX	THOS.E.HARPER	(EDITOR PUBLISHER)	CORNING			SANTA ROSA	
Dr. L.E.STARK	(DENTIST)	AUBURN	S.C.JUDSEN	(CONTRACTOR)	COLUSA				
C.H.MALLEN	(MINE SUPT)	NEVADA CITY	L.L.BREWER	(AGENT S.P.Co)	WILLOWS			PETALUMA	

most of the land to the Los Altos Golf and Country Club. Its Catholic heritage lives on, however, in the railroad stop's name, Loyola Corners.

The Los Altos Comet

Vol. I LOS ALTOS, Santa Clara County, CALIFORNIA, May 6, 1912 No. 1

NEW STATION IS AN ASSURED FACT

THE OLD BOX CAR MUST GO

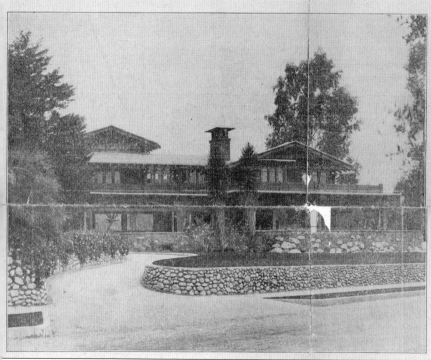

Tremendous Enthusiasm on the Part of Railway Officials Presages Magnificent New Depot For Crown of the Peninsula

Fifty Commuters, representing the flower of Los Altos, both north side and south side, gathered in front of the Old Box Car yesterday morning just before The Bullet pulled in and rent the early morning air with cheer after cheer for Superintendent Ahern, Traffic Manager Fee, Vice-President McCormick, President Sproule, and Chairman Lovett, as the news was told that the stationless Crown City had added these names to its army of supporters in its valiant struggle to assist the grand old Southern Pacific

Walter Clark published this newspaper, the *Los Altos Comet*, as well as the *Los Alto Star*, several times from 1908 to 1913 as promotional efforts. In one issue, Clark joked that he was the only subscriber so far, at a cost of $1 a year. These early newspapers give a fascinating picture of what they wanted the new town to look like (this depot design was not chosen) and reflected Clark's optimistic view of what it might be in the future.

Four

EARLY RESIDENTS AND BUSINESSES

The first houses built in the new town of Los Altos were along Orange Avenue, as shown here. All exist today. The home second from left was built in 1909 by Charles Denny's family. As a boy, he made a crystal radio set that picked up occasional broadcasts from KLP, whose aerial wires he could see from his room. KLP was run by Emile Porter, an engineer for the Colin B. Kennedy Company, also broadcast experimentally as 6XAG. A 1921 article reported his notable success, headlined "waves ignore lofty peaks—a Radiophone station in Los Altos Calif. has broken all records by sending messages 2,000 miles overland to Great Bend, Kansas."

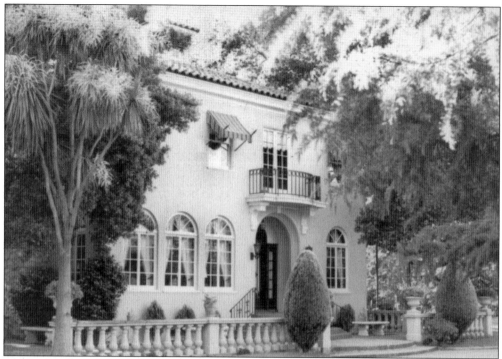

Frank Marini built this lovely Italianate home on University Avenue in 1926 for his four maiden sisters and himself. Its four levels (7,200 square feet) feature fine woods and many special touches, like beveled-glass French doors. Meticulously restored with antiques of the period and surrounded by 2 acres of landscaping extending across Adobe Creek, the home is a prime showcase estate of "old Los Altos."

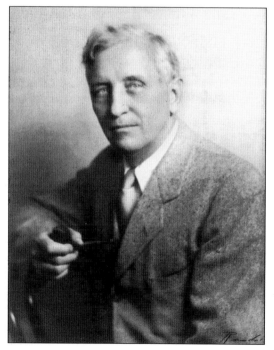

Herman Peters was a principal figure in early Los Altos years. He began by renting the old Merriman house, the former Chandler School for Girls, for his Los Altos School for Boys and Young Men in 1911. After it failed, he established the town's first independent real estate and insurance office on Main Street with telephone number 1; organized the first Boy Scout troop in Los Altos in 1918, serving as its first Scoutmaster; spearheaded the successful fund drive for Scout Hall in 1922; and later served as a member of the state railroad commission.

Margaret Wallace, the wife of Ryland Wallace, sits on the steps of Red Gables, her East Coast–style "cottage" built in 1911 for summer entertainment. Situated on the corner of University Avenue and Burke Road, the home has a history tied to the name of Leland ("Lee") Smith, the black chauffeur and handyman who lived there many years. He was hired in 1922 by Mrs. Wallace, who had become a reclusive widow by then. Because she rarely used him for work, he busied himself with helping others around town and in doing so became popular as the town's unofficial "mayor."

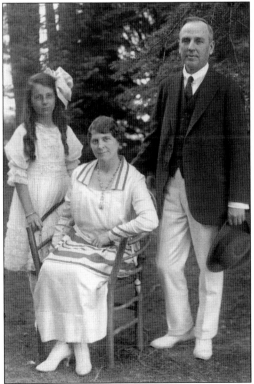

Guy Shoup is shown here with his wife, Adelle, and daughter Faith. Like his brother Paul, Guy had a Southern Pacific career, becoming its senior attorney. He also lived on University Avenue from his arrival in 1909 to his death in 1965. He was always active in civic affairs and a founder (later president) of the First National Bank of Los Altos. In 1919, he produced the film *Rebecca* as a relief effort for World War I and a series for the Union Church called *Sparkles Family and Their Neighbors.*

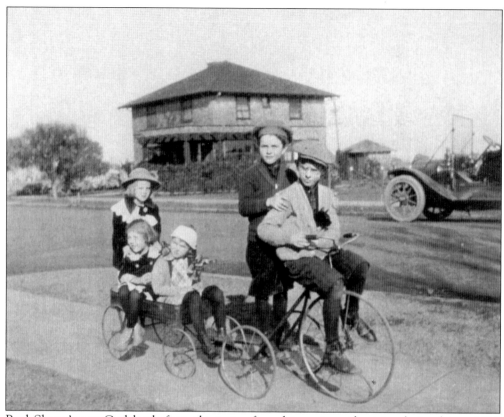

Paul Shoup's son Carl leads four playmates from his seat on the tricycle in this c. 1915 photograph taken near the Shoup home on University Avenue. The Marvin O. Adams home is in the background.

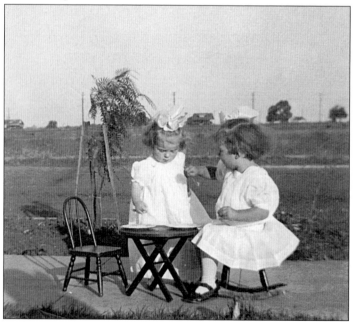

This little tea party took place around 1915 along University Avenue, probably in front of the Carl Shoup house. The participants were Francis Shoup and her cousin Marjorie Robinson, who was the first child to be born in the newly established town of Los Altos, in 1909.

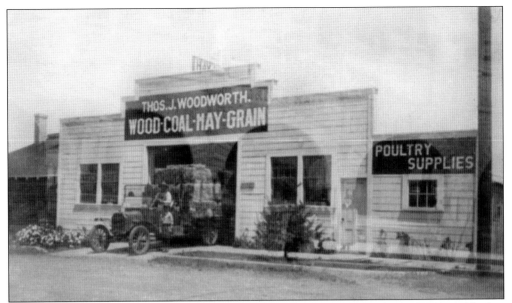

Thomas Woodworth began his fuel and feed business on the east side of First Street and built a house next door. Soon he extended his business to a warehouse across First Street, conveniently located next to the freight depot.

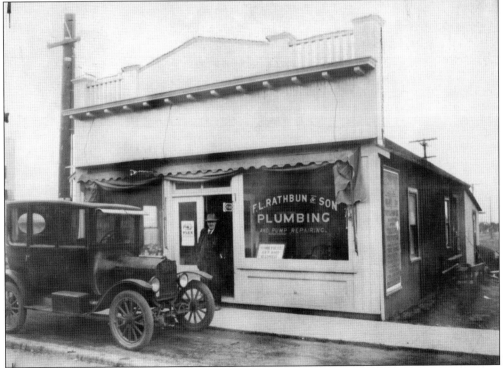

In 1911, Frank Rathbun opened the first plumbing shop in Los Altos in this building (since destroyed). It had once served as a restaurant for workers laying out the streets and sidewalks of the new downtown in 1908. He also drilled wells, which was a much-needed business for the many nearby farms.

Around 1910, Dr. Thomas Shumate bought 400 acres in the Los Altos hills between West Fremont, Concepcion, and Purissima Roads and planted much of it in walnuts. The early house and garage shown here were later joined by a mansion, which housed the Happy Hours Nursery School after Shumate died in 1952. The Fremont Hills Development Company subdivided his land, and some became the sites of the Fremont Hills Country Club and Fremont Hills Elementary School.

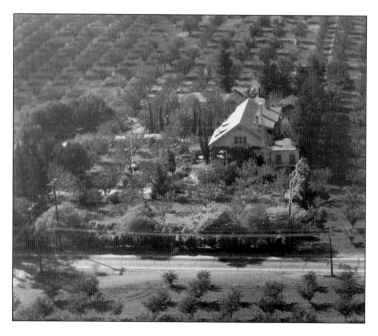

San Antonio Road still had only two lanes when this photograph was taken of the home of Dr. Paul Myers, built for his retirement in 1912. He died soon after, and his widow became well-known around town for driving one of the early electric cars. In the 1950s, the downstairs room and its pool table provided nearby high school students with a favorite hangout spot. From 1960 until 1985, the house was used for the Happy Hours Pre-School.

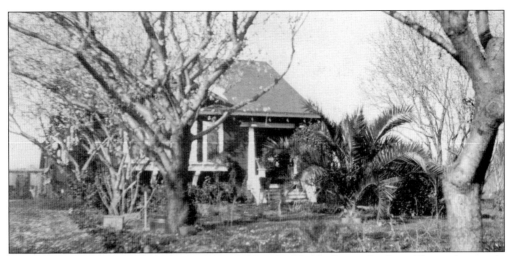

This is an early photograph of the Herman and Bertha Bleibler house, built on Cherry Avenue in 1913. It was on several of the 2-acre lots in the first local subdivision with "small lots for people who wanted room out in the country for a little farm" but not a commercial orchard. Bleibler's iron-working business in Palo Alto forged construction ornaments. The Bleibler house is now owned by a grandson, and other Bleibler progeny also live in the Cherry Avenue neighborhood.

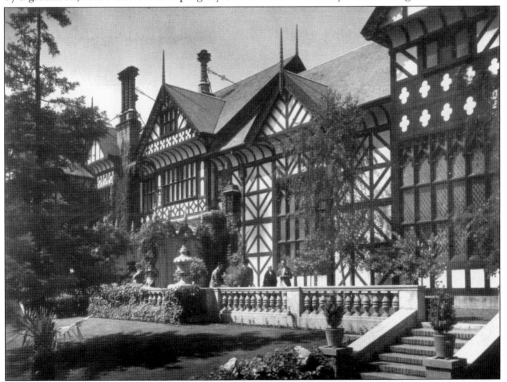

Finished in 1916, Morgan Manor was the "English castle" of Percy Morgan Sr., a wealthy Englishman. Its exterior is a copy of Speke Hall near Liverpool, England. Many exquisite Gothic and Renaissance details inside and out were imported from Europe, such as the painted ballroom ceiling from the palace of a Venetian doge. The landscaping boasted rosebush cuttings from the Alhambra. The Manor today is still one of the most beautiful edifices in Los Altos Hills.

Sec. 562—P. L. & R.
U. S. Postage
PAID
Los Altos, Calif.
Permit No. 18

LOS ALTOS
P. O. Box Holder

LOS ALTOS NEWS

VOL. I LOS ALTOS, CALIFORNIA, FRIDAY, MARCH 11, 1938 NUMBER 3

136 ENTHUSIASTS ENDORSE NEW FOOTHILL BOULEVARD

Meeting Attended By Representatives of Three Counties

Realizing the need of supplying commuters who drive to San Francisco daily with a fast-safe highway, that will offset the advantages the bridges offer East Bay and Marin commuter traffic, the peninsula counties, San Mateo, Santa Clara and Santa Cruz got together in a big way at the Los Altos Country Club the evening of March 1 to learn what could be done. Presided over by Alfred Spinks, president of the local chamber of commerce 136 men and women interested in knowing more about the

Los Altos School To Have New Bus

The board of school trustees announces with pride that Los Altos will soon have the very finest modern school bus that can be built. A 57-passenger, custom built Dodge with all steel body, safety glass throughout, and every up to the minute safety device has been ordered. Chassis was purchased through George Ramsey, and body is being built by Barshow and Baleria, San Jose, who have built over 75 per cent of the school busses in this county. With the new, large bus only

WHAT DOES IT MEAN TO YOU?

What does it mean to you, when unexpected visitors drop in and your refrigerator is empty, that you can get what you need from the LOCAL creamery, grocer or liquor store?

What does it mean to you, when your car won't start, or you've had other car trouble, that you can get help, day or night, from your LOCAL garage?

What does it mean to you, when sickness or accident strike suddenly, that your LOCAL drug store will give you service and delivery at any hour?

Does it mean that you should patronize these local standbys only in time of emergency, and take your business elsewhere while they starve, or fail, for lack of your steady support?

Vaudeville Show To be Given By P.T.A. March 18

Are you one of the people who says "I'd give a good deal to be able to see a good old vaudeville show again?" If you are, get your reserved seat right now for the "Varieties of 1938" March 18. Seven acts, every one professional, top-bill type, the like of which we have not seen since the Orpheum was the one place we were always sure to find a good show.

Our P.T.A. was plenty smart when

The *Los Altos News* was the town's first real newspaper. It began publication in 1917 as a weekly and, after ceasing operation during the Depression, started again in 1938 with this fancy masthead, which soon was simplified. It continued until the end of 1966, by which time it had become overshadowed in popularity by its friendly rival, the *Town Crier.*

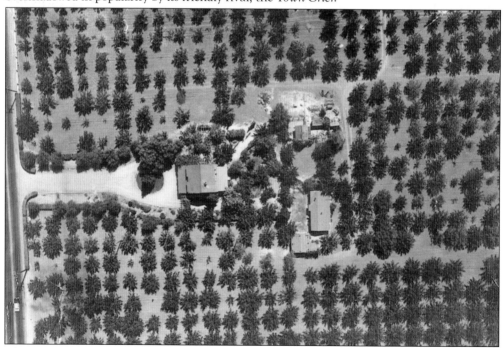

This 1952 aerial photograph shows the Manning house before it was later subdivided as part of Maynard Way and the Alma Court subdivision took up the upper area. When his orchard work permitted, Gilbert Smith worked as a builder and contractor. He built this house in 1908, and the Manning family bought it in 1925. Daughter Arah Manning Love built the Wooden Shoe Pre-school there in 1947 and ran it until the property was subdivided in 1983.

This 1920 photograph shows Rose (Mrs. Paul) Shoup standing on their Japanese garden bridge with a niece and nephew. Such gardens were often built along Adobe Creek in the 1920s, and they generally met a common fate of being washed out in periodic creek flooding.

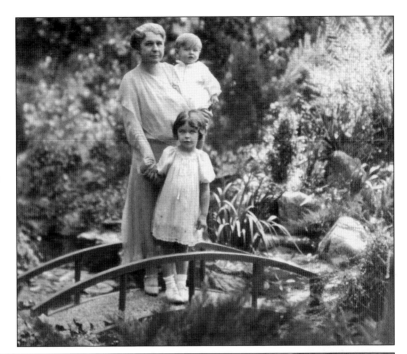

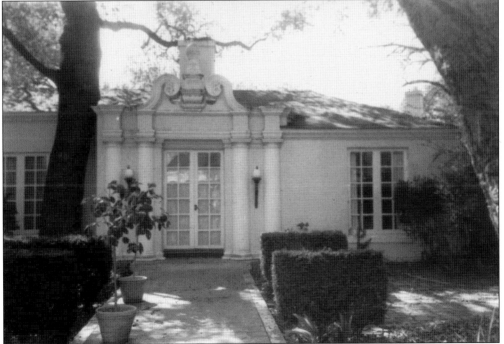

Ernest Coxhead, architect of the town's Congregational Church in 1914, designed this "summer cottage" for Dr. Reginald Knight in 1917. Located at the Adobe Creek end of Yerba Santa Avenue, it was surrounded with exotic trees to complement the home's light and airy atmosphere. Not shown here was a later addition along Adobe Creek—an attached, self-contained unit with a ballroom. Artist Renaud Hoffman owned it in the 1940s and used this unit for his studio and his students.

Canyon Road Inn, along Moody Road, was the first in what was sometimes termed the El Monte Canyon. It opened in the 1920s and operated as a store, beer parlor, and dance hall, besides selling gas and oil. It closed down in 1942. It is now a private home.

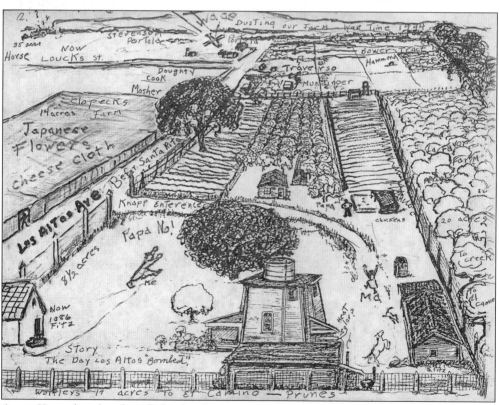

Anton Knapp bought a farm for his family in 1921 on Santa Rita Avenue (later Los Altos Avenue). Daughter and self-taught artist Annie Knapp Fitz sketched this World War II–era scene showing their neighborhood as she remembered it. Annie drew and painted the area's history, publishing *Looking Backwards—Historical Sketches* in 1984. Her stories still captivate schoolchildren on tours at the Los Altos History Museum. She left hundreds of paintings and many sculptures to the museum.

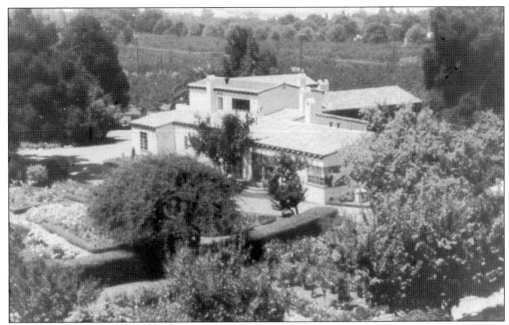

Some wealthy San Franciscans chose to build their retirement or second homes on Los Altos Avenue. William Marvin was one, buying 10 acres in 1922 after he retired as a young millionaire from his international law firm. There he built Casa Reposa, pictured here. It was a Mediterranean-type villa with a formal ballroom, surrounded by large oaks, orchards, formal gardens, an Olympic-sized swimming pool, cabana, patios, a classic stone grotto, and pond. Although considerably modified over the years, Casa Reposa survives today as an elegant home.

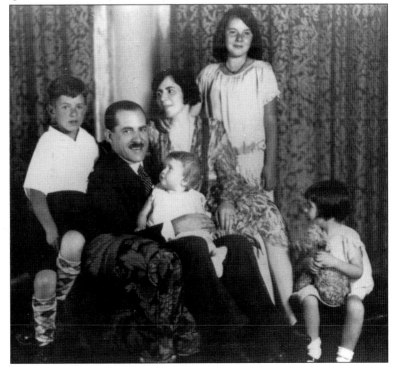

This is the William and Charlotte Marvin family. The children, from left to right, are William Jr., Barbara, Dorothy, and Elizabeth.

BETTY JEANE PRODUCTS HAVE HOME PLANT HERE

A tiny vine-clad bungalow in the midst of a garden all in bloom; a long low shed, gleaming with white paint beneath the green of the fruit trees; the whole set in the center of orchards of the Santa Clara valley, near Los Altos—that is the home of Betty Jeane, Inc. From this spot come the jams and honey served in the great hotels and clubs of the Atlantic Coast; this is the source of the stuffed and dried fruits which grace the tables and side-boards of wealthy homes all over the United States; from here came the fruit and honey with which every guest in the Hotel St. Francis in San Francisco was served on Eastern morning. Betty Jeane's plant—the home of "very best" delicacies.

In 1922, the *Palo Alto Times* ran this article about Betty Jeane, Inc., making jams and jellies "in a long white shed behind . . . a tiny vine-covered bungalow in Los Altos." The business had started in 1920 and had considerable success turning local fruit into a high-quality product for upscale restaurants. This bungalow survives on San Antonio Road, but the shed is long gone, as is the business, which was sold to a large commercial food company, Mary Ellen's, which was acquired by Smucker's..

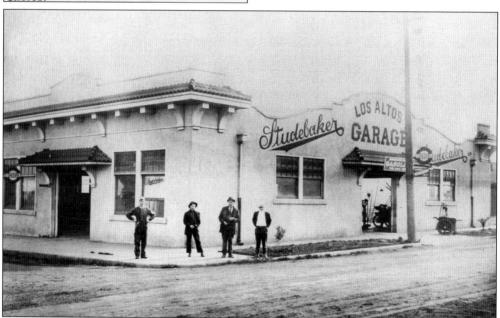

George Ramsey bought an old boarded-up garage at the corner of State and First Streets in 1924. He built up a good business with men who left their cars for servicing during their daily train commute. He was a key person in the volunteer fire department, housing its truck and equipment. He expanded into auto sales of Studebakers, as shown here.

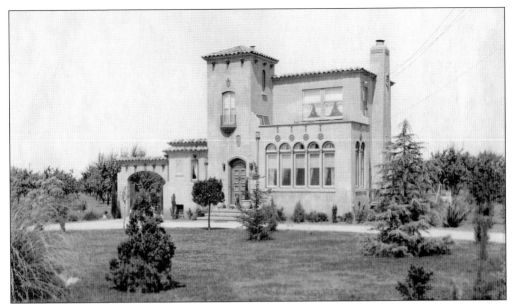

This is San Francisco architect Andrew Knoll's Italian Renaissance–style house at Angela Drive and San Antonio Road. "Villa Angela" was built in 1922 and featured a curving stairway, 200-year-old Belgian floor tiles, limestone counters, unique plaster plaques, and a floor-level kitchen hearth. It was restored and enlarged in the late 1980s.

In 1924, Albert Diericx bought a 7-acre lot on Los Altos Avenue near Mount Hamilton Avenue, where he built a grand, Mediterranean-style, two-story, nine-bedroom home, the entrance to which is shown here. Diericx commuted to San Francisco to his job as a marine architect and engineer for the Matson Navigation Company. The most important outbuildings and the formal gardens survived after a 1950s subdivision reduced the property to its present size of an acre.

Surrounded by trees, this is the mansion in Edward McCutcheon's Twelveacres Estate, built in 1924 on the Adobe Creek end of Pine Lane. Except for some estates in the hills, this was the most expensive Los Altos property in the 1930 U.S. Census. McCutcheon was a wealthy, retired San Francisco attorney, whose nationwide firm survives today as Bingham McCutcheon. The trees in this photograph block sight of the estate's elaborate landscaping designed by his friend John McLaren, of Golden Gate Park fame.

This home on Almond Avenue is typical of the Spanish Revival architecture popular in 1928 when it was built by Dr. Daniel Smith, a retired dentist. He acquired the nickname "Concrete Smith" because of his enthusiastic use of concrete as driveway curbing and along other borders, as well as for the fishpond. Originally built on 6 acres, the house now sits alone, without its original garage (with a "lube pit") and sunken wine cellar.

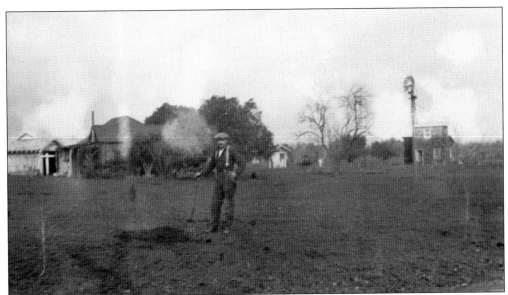

This 1926 photograph shows Nicholas J. C. Van Stratten planting his new 5-acre apricot orchard along El Monte Avenue, near Benvenue.

Frank and Kathryn Taylor moved near downtown Los Altos in 1929 with their three sons and later moved to a larger place in the hills where he could work, as shown here, in his garden—one of the many subjects he wrote about. Frank was perhaps best known for his short stories in the *Saturday Evening Post* and *Colliers* magazines. Kathryn was also a published author, her best-known book being *Yosemite Trails and Tails*.

Joseph Becker Jr. married Alma Bleibler, a neighbor and schoolmate at Los Altos Grammar School. They are pictured here at Yosemite with daughter Viola in 1930. Later Viola also married a classmate living on the same block, Ralph Clifford. After the 1906 earthquake, Joseph Becker moved his wife, Agnes, and their two sons to a 10-acre lot on Los Altos Avenue, developing it as an apricot orchard and chicken farm whose eggs were trucked in flats to San Jose to become part of the county's sizeable egg export business. Most of the Becker orchard was subdivided as Becker Lane and Patrick Way in the 1950s.

This 1930 Spanish-style home on Del Monte Avenue was built in the Los Altos Park subdivision off San Antonio Road. Developed in 1925, it was the first area subdivision of very small lots for modest homes. A second story was harmoniously added to this home in 1936, and it is surrounded by huge sequoia trees, demonstrating how large they can grow in 80 years, given that normally they would have experienced significantly more rainfall in their natural range on the ocean side of the Santa Cruz Mountains. The girl on the left is Ruth Job, later Mrs. Wallace Ericson.

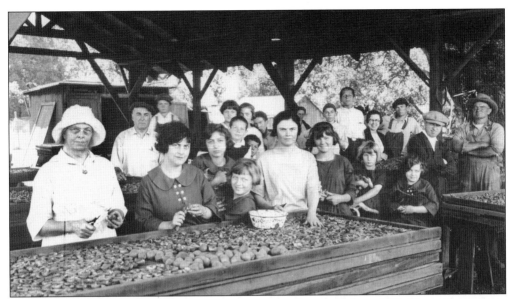

The McKenzie family and friends are cutting apricots in their shed about 1923. The two prominent ladies at the table are Mary McKenzie (left) and Ellen McKenzie (center). Mary's husband, Michael, is at the far right, with folded arms.

This 1930s house was built on the footprint of the 19th-century Alta Vista Ranch farmhouse. It was completely rebuilt in 1997, with the addition of a wraparound wooden porch, arbor, and guesthouse. Near the house, just over Adobe Creek, a 1930s barn built for horses is one of few left in Los Altos.

Edgar McDowell took this photograph in 1937 of his family in the yard of their University Avenue home. From left to right are Alice, Elsie, Betty, Laura, Jim on the tricycle, J. E. Sr., J. E. Jr., and Jacob J. Nagle. Edgar worked as Paul Shoup's personal secretary and assistant and led the Los Altos Boy Scout troop as scoutmaster in 1924, 1926, and 1934. Nagle lived nearby and wrote newspaper articles in 1927 "proving conclusively" that the author of Shakespeare's plays was actually Francis Bacon.

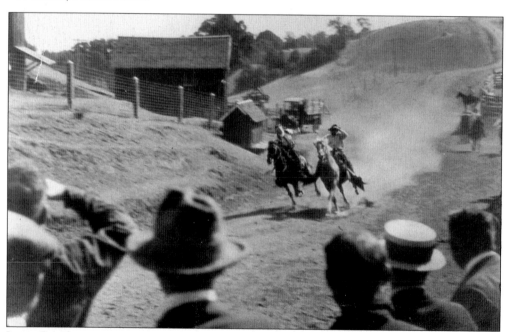

Louis Oneal, a prominent San Jose attorney, was active in 1930s Santa Clara County politics. His 1,200-acre O&O working cattle ranch near Alpine Drive had gauchos to manage the stock and attend to the orchards. Oneal was a great lover of horses and would occasionally hold rodeos, parties, and weekend events at his ranch, such as the horse race pictured here.

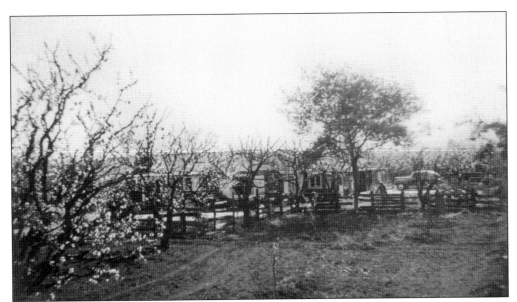

This orchard-surrounded house on North Gordon Way near Almond Avenue was built in the 1940s with walls of adobe bricks actually made on the spot. Its large living room allowed former owner the Bryans to furnish it with two grand pianos. Rosemary Bryan was an opera singer and friend of the concert pianist Jorge Bolet, who lived at that time in the nearby hills. On one memorable evening, Bolet played duets there with his violinist friend, the famed Mischa Elman, who was in town touring at the time.

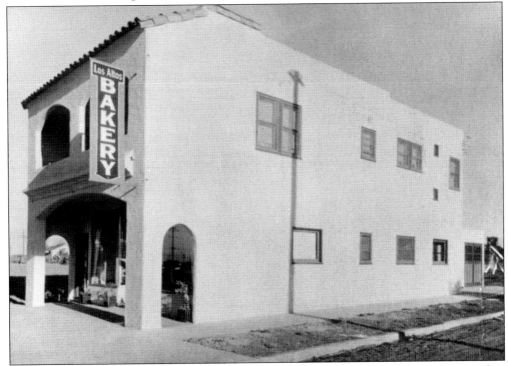

The Los Altos Bakery, built in 1929 at the corner of Main and Second Streets, was the area's first real bakery. The bakers were Andrew and Emma Oehlschlager.

This early photograph of the small town was probably taken from Gilbert Smith's upper-floor window around 1913. San Antonio Road runs across the lower part, and a curving piece of Main Street can be seen halfway up the right edge of the photograph. The Shoup Building is on the right (with five windows on its second story).

Five

EARLY COMMUNITY INSTITUTIONS AND MOVEMENTS

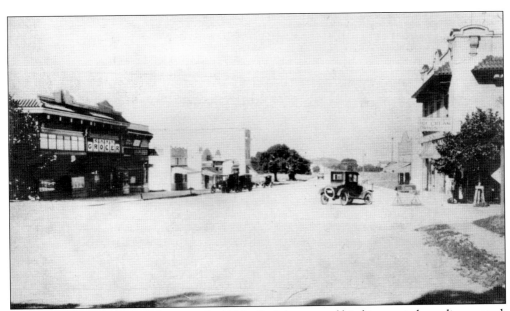

This was the scene on Main Street in the 1920s. Both horses and hitching posts have disappeared. Despite some vacant lots, the business section of town was beginning to take on the look of a downtown village—a look that careful zoning laws have tried to retain to the present, partly by restricting building height. The only paved streets in those early years were San Antonio Road and Main, State, and First Streets.

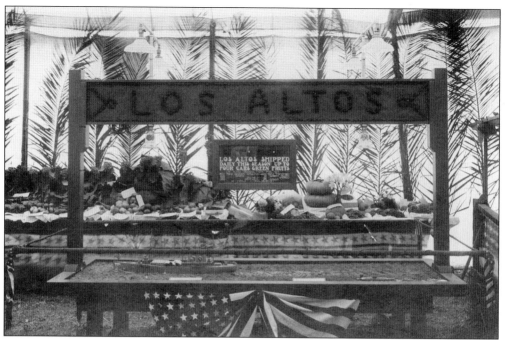

The Los Altos display at the 1917 Santa Clara County Fair boasted four freight cars' worth (100 tons or 200,000 pounds) of fruit—a day. This hand-painted list of annual production lists 1,500 tons of green and 200 tons of dried apricots, which is no surprise to those who associate Los Altos with this delicate fruit. Dried prunes accounted for 700 tons. Less-remembered local produce included dried peaches (500 tons), cherries and green plums (10 tons each), and pears (120 tons green, 25 dried). Forty-eight hundred tons of tomatoes implies a much larger "Los Altos" than today's boundaries.

Guy Shoup produced a film in 1919 to raise money for Belgian postwar relief. He wrote the script, directed the players, and got the Southern Pacific Railroad to provide technicians and equipment and to stop a train at the right spot and time. The resulting film, *Rebecca*, raised $500 when shown at the Ng Tong Temple. A caption began the action: "Los Altans Pursue Kidnappers Down Main Street!" This photograph shows the villains, William Ames, Guy Shoup, and Albert Robinson. They were pursued by grammar school students and frantic town residents throughout almost the entire town when—horrors!—a train appeared and stopped across Main Street, blocking the pursuers. In the end, Rebecca was rescued, but sadly, the film has been lost.

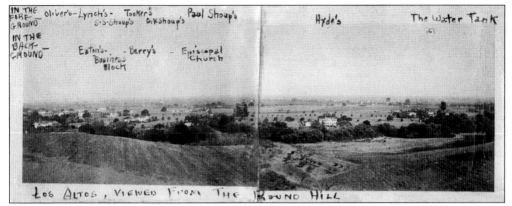

IN THE FORE-GROUND — Oliver's – Lynch's – Tooker's Paul Shoup's Hyde's The Water Tank
 S.S.Shoup's G.K.Shoup's

IN THE BACK-GROUND — Eaton's – – Berry's – Episcopal
 Business Church
 Block

Los Altos, Viewed From The Round Hill

This 1920s snapshot with some landmarks identified was taken from the hill between El Monte and Fremont Roads, locally known as Mount Madonna. Most of the houses shown were on University Avenue. The photograph shows how little construction had taken place by that time. The hill is thought to have been the site of Juan Prado Mesa's 1848 adobe; Mesa was the original grantee of Rancho San Antonio.

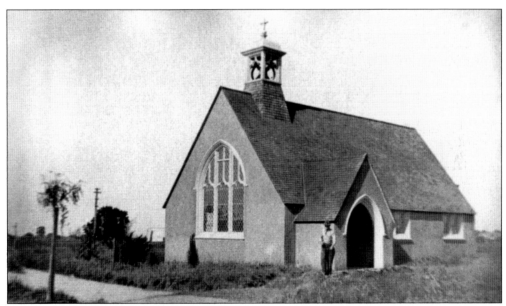

The earliest church services in Los Altos were held in 1908 by the Methodist Church in the Shoup Building. Shown here is Christ Episcopal Church, the first church built here, in 1914 on Orange Avenue. It later became Foothills Congregational Church. The First Baptist Church was built on Main Street in 1947, and later the congregation built its present church on Magdalena Avenue. Roman Catholic services were held in Scout Hall before 1927, and after that, they used the Jesuits' El Retiro until St. Nicholas was built in 1942. The First Church of Christ, Scientists, Los Altos, on University Avenue was dedicated in 1926.

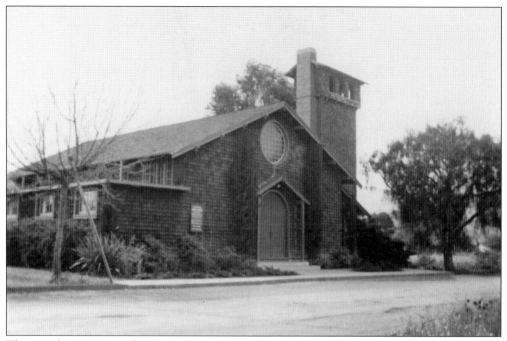

This nondenominational Union Church was built in 1914 on San Antonio Road and became fondly known as the "Little Brown Church." Its pastor for many years was Rev. Thomas Landels. The Seventh-day Adventist Church used it during the years before they could build their own. When the Union Church was later torn down, its congregation moved to become the Union Presbyterian Church, built on University Avenue.

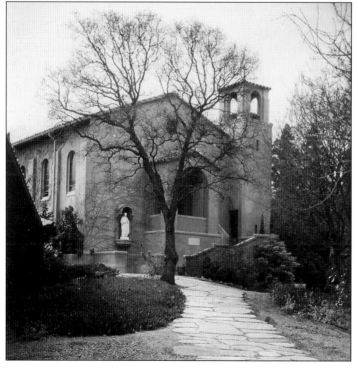

William Wellman built a large estate on a hill rising above University Avenue in 1913. His Spanish Mission–type home has a fine view looking northeast over Los Altos. In 1927, the Jesuit Order bought the estate and some adjoining land for a laymen's retreat. They soon built the Rossi Chapel shown here. Its neighbors have often expressed pleasure at hearing men singing and chanting on quiet evenings. (Jesuit Retreat Center of Los Altos.)

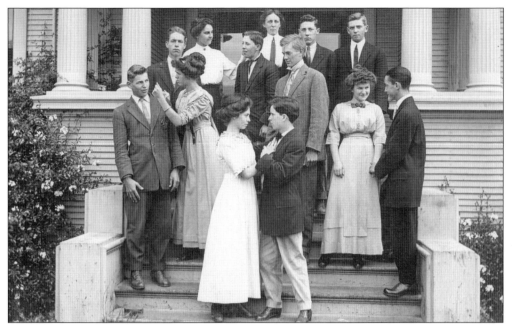

Only Charles Ernest Loucks is identified (right end of the upper row) in this photograph of members of the 1913 class of Mountain View High School. He graduated from the Los Altos Grammar School, and most similar graduates attended Mountain View High School until the Los Altos High School was built in the 1950s. Loucks later became a major general in the U.S. Army.

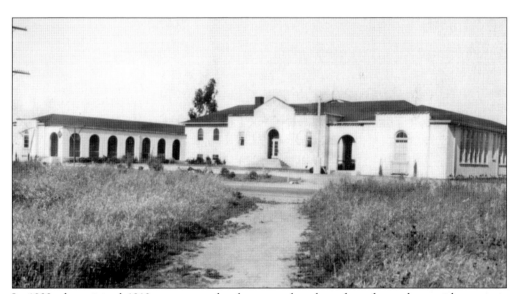

In 1922, the original 1913 grammar school was much enlarged, as shown here with two new wings and a proper auditorium. This latter feature, together with the stage in the new Scout Hall, replaced the upstairs room of the Shoup Building for various civic functions. The auditorium was also used for showing silent movies in 1925.

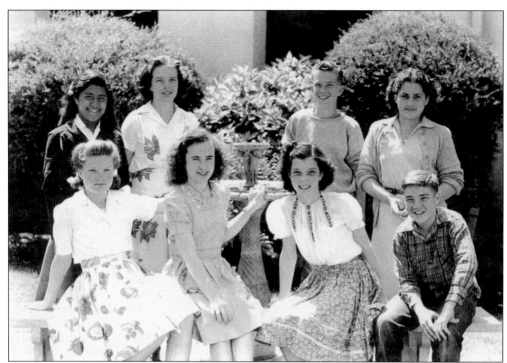

As early as 1927, the PTA urged the school district to form a kindergarten, as 25 children of that age were living here. The first class was finally formed in 1936. Eight years later, when that class graduated in 1944, the above photograph was taken of eight of the students who were in that first kindergarten class. During World War II, the class size of the kindergarten doubled.

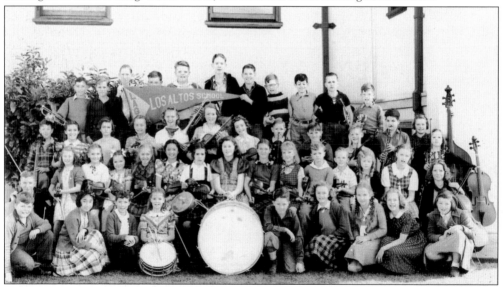

Helene Baxter was hired in 1927 to teach a grammar school musical enrichment program. A professional violinist, Baxter developed a relatively accomplished orchestra, personally teaching many of its members. The PTA helped by buying instruments, and the local Japanese community donated funds. This photograph shows the 1939 orchestra, a tribute to her enthusiasm, numbering 47 students out of a total of 300 in grades three through eight.

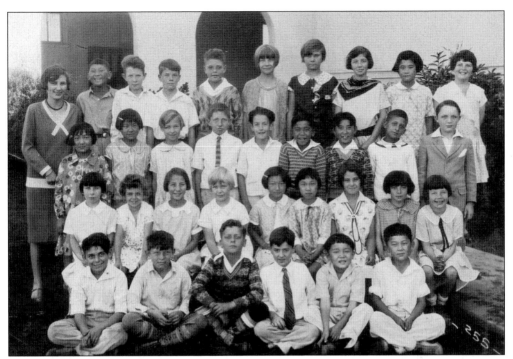

This 1930 photograph of the grammar school fifth-grade class shows a diverse local population. This was also discernable in the 1930 census, where fully a third of the adults living in the greater Los Altos area had a "mother tongue" other than English. An equal percentage worked in agriculture, which used about 70 percent of the land. Only 8 percent of local women worked at jobs outside their homes. Now-obsolete occupations abounded, like typesetter, and many were listed as "boarders" or "roomers." A majority of the homes owned that modern invention, the radio. There were 74 World War I veterans listed and 16 from the Spanish-American War.

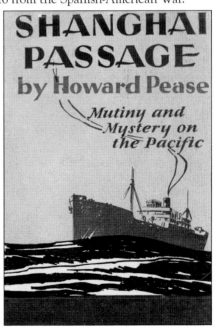

Howard Pease taught in the Los Altos Grammar School in 1928 and was its principal for a few years beginning in 1931. He wrote popular adventure books for boys like this one. *The Ship Without a Crew* (1934) was inscribed to Mervyn Lea Rudee, a local boy who lived on San Antonio Road, "because the book was written in the cabin in his backyard."

When formed in 1918, the local Boy Scout troop met in the Shoup Building. In 1920, a drive was launched to get Scout Hall built. One money-raising scheme featured prominent Los Altans in a 10-act vaudeville show. The drive raised $7,000, and the finest Scout Hall in the county was built on First Street. It had a stage, dressing rooms, and basketball court and housed the town library. Its grand opening featured Stanford's Glee Club in songs, special stunts, and "old-time minstrel jokes and other high-class features."

Here is a photograph of local Scouts at Yosemite in 1923. From left to right, they are Marshall Mull, Francis Scheid, Steve Pagson, and scoutmaster Edward B. Harper. The district changed the local Troop No. 1 designation to Troop No. 27. For several years, the Scouts organized Twelfth Night bonfires out of old Christmas trees in the open field across First Street. Another activity they organized was a 1925 dance at Scout Hall for the Girl Scouts.

Here are local Girl Scouts, helping at the 1934 Flower Show under their leader, Myrtle Formway (on the right). Formed in 1922, they had grown into three troops and one Brownie pack by 1931. For outdoor activities, they acquired Camp Sycamore in the Santa Cruz Mountains. Rose Shoup (Paul Shoup's wife) was very active in the organization, as was Dr. Charlotte Marvin.

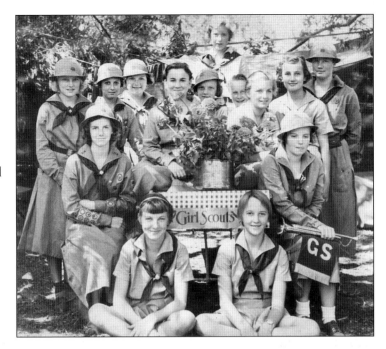

SAMUEL G. TOMPKINS
ATTORNEY AT LAW
ROOMS 5, 6, 7 AND 8 AUZERAIS BUILDING
SAN JOSE, CALIFORNIA

SAN JOSE, CAL. *Mch 6th 1918*

Dear Mr Deuhart—

We who are interested in endeavoring to have our next State Legislature ratify the national constitutional amendment for nation wide prohibition of liquor, realize the importance of having those favorable to this movement, register at once for the primary election soon to take place—

This was a typical "get out the vote" letter of proponents of Prohibition. Like the rest of America, Los Altos went through a dry period from 1919 until 1933, when the 18th Amendment was in force. For thirsty Los Altans, Fred Riccomi was probably the most popular bootlegger. He dispensed refreshments from his 25-acre orchard, now the site of the San Antonio Center in Mountain View. Riccomi was adroit (or lucky) enough to avoid arrest.

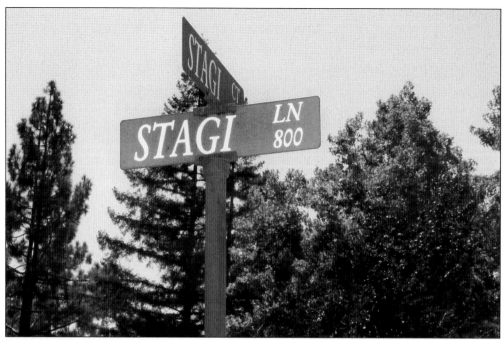

The biggest local haul by the enforcers of the Volstead Act took place in March 1929 when they apprehended Teresa Stagi with 2,000 gallons of wine. This 70-year old Italian lady had a large vineyard on the hill locally called Mount Madonna, and her name survives in today's Stagi Lane and Stagi Court. (Lisa Robinson.)

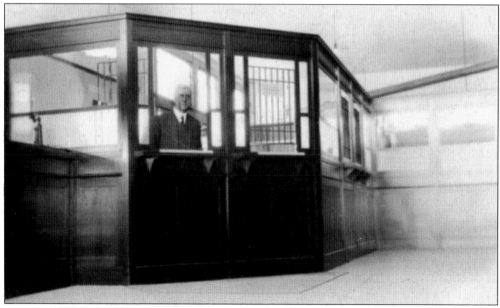

Investors led by Paul Shoup founded the First National Bank of Los Altos in the building once occupied by the Altos Land Company. Excitement occurred when it was robbed in 1928; a car chase of the bandit ensued, but he escaped in a cloud of dust, speeding through some Almond Avenue orchards. Shown in this photograph is William T. Clements, the bank's manager, who was slightly injured in the incident. The building survives today at the corner of First and Main Streets.

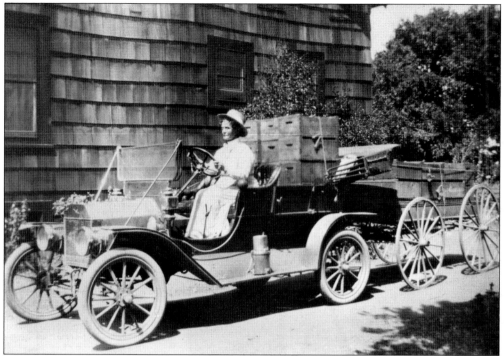

This photograph of Gilbert Smith's mother, Mary Shane Smith, shows her ready to take a load of apricots to the packers in Mountain View. In a 1931 survey, apricots were Santa Clara County's chief crop, accounting for two to three times the acreage of other crops. Prices paid for some crops depended on the availability of refrigerated freight cars for shipping fresh fruit east. (California History Center, DeAnza College.)

This is what the land west of Loyola Corners looked like about 1924. When the Jesuits gave up plans to build a university here in 1923, they sold 620 acres to Los Altos Country Club Properties, which used 155 acres for a clubhouse and golf course. The rest they subdivided into 110 large home sites ranging from one to 16 acres. These lots were eventually subdivided at least once. Although considered part of Los Altos, the area has always been county land.

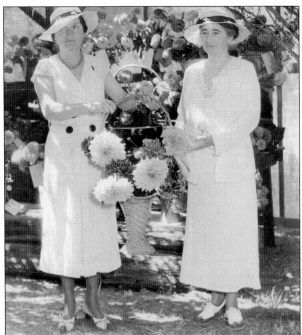

When Los Altos was formed in 1907, Paul Shoup made it clear that part of his land on Adobe Creek should someday become a park. That day arrived in 1930 when it was decided to hold the first annual Los Altos County Flower Show there. Volunteers cleaned out weeds and trash, did some landscaping, built restrooms and refreshment stands, and installed utility outlets. It became an official park after Los Altos was incorporated in 1952.

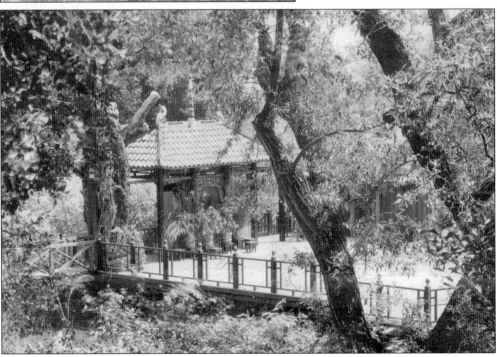

Where their back lawns met at Adobe Creek, five families built Ng Tong Temple as an open-air pavilion. With its brilliant vermillion pillars supporting a yellow tile roof and illuminated with lanterns, the temple was noted for its "strange beauty." Entertainments and other events were held there, such as an "elaborate musicale" in the early 1920s called *Farewell to Pan* honoring the Cuban Consul. Some 125 guests dined in the gardens, and 300 others joined the party later for the music. Many guests were from San Francisco's exclusive Bohemian Club.

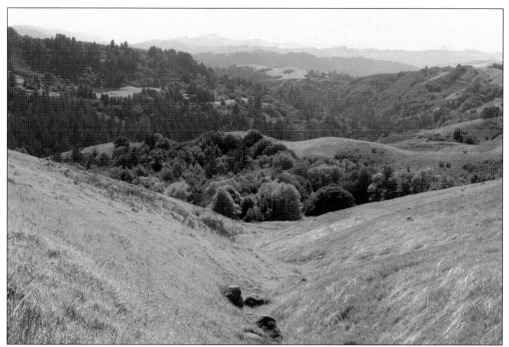

This is a modern view of the Russian Ridge Open Space land. In the 1910s, this land was part of the large ranch owned by "Sunny Jim" Rolph, the longest serving mayor of San Francisco (1912–1931) and California's governor (1931–1934). The media often described his Alpine Road ranch as located "west of Los Altos." Sunny Jim's home was destroyed by fire in 1913. He was the only one in the house at the time. Louis Oneal and others tried to save it, to no avail. (Creative Commons CA.)

This 1923 road map was the earliest published by the California State Automobile Association showing Los Altos—an area widely extended in all directions from the original town plat acreage.

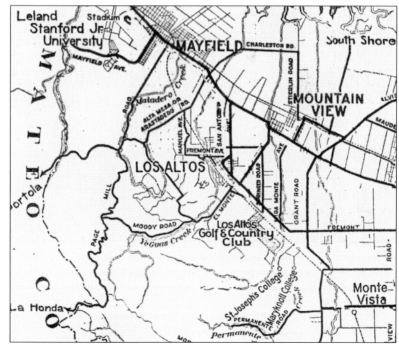

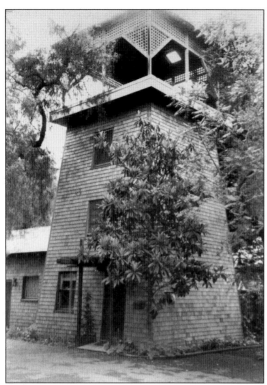

The Los Altos Community Players, the first local theatrical group, began rehearsals inside John and Norma Wideman's tank house on San Antonio Road, shown at left. (The original 1915 farmhouse and tank house survive today.) They produced their first show, *The Hidden Guest*, in May 1934 in the grammar school auditorium. Later the Los Altos Community Players broadcast several one-act plays over radio stations KQW and KJBS.

Joseph Mora was a well-known sculptor and painter from Uruguay. Among his best-known works were the diorama of the Portola Expedition for San Francisco's 1939 Golden Gate International Exhibition on Treasure Island and the bronze statue of Christ for Santa Clara's Catholic cemetery. His home and studio were in Los Altos Hills on Mora Drive, named for him, shown below as it begins its ascent west into the hills.

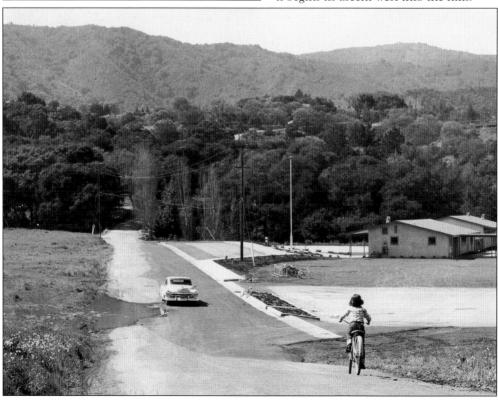

In 1913, the telephone company installed first local service in the home of its agent, Charles Schmaling. His wife, Mary, and daughter Edith operated the 32-connection switchboard, helped by Ernie Becker, a live-in orphan. He remained in the business after it was changed to direct company control in 1915, and made it his career. In 1940, the company moved to its own building on State Street. Annie Knapp Fitz, who worked there before dial-service was installed, made this sketch.

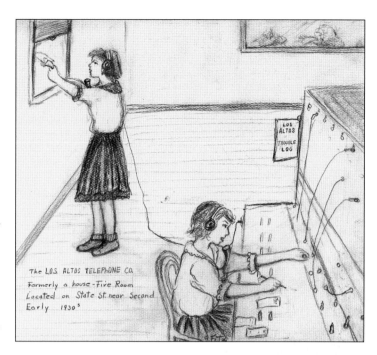

The LOS ALTOS TELEPHONE CO.
Formerly a house - Five Room
Located on State St. near Second
Early 1930's

LOS ALTOS MEN'S CLUB FEATURE OF COMMUNITY LIFE

Dinner Meetings Are Held Each Month With Lectures by Notable Men.

Editor's Note: This is one of a series of articles about Los Altos. Similar articles on other communities of the valley will follow.

By JOSEPHINE HUGHSTON.
Staff Correspondent.

LOS ALTOS, Mar. 12.—Los Altos is a community of a rather exceptional order, and its social organizations reflect the type of the community. There are several clubs which help to enrich the social life of the place, and which number among their members people of prominence and education.

The Los Altos Men's club is one of the interesting groups in the community. Dinner meetings are held by the club on the second Thursday of each month. There is always a speaker at the meetings and Senator James D. Phelan, Senator Samuel Shortridge, Ray Lyman Wilbur, ex-president of Stanford university and now a member of President Hoover's cabinet, and many other notable men have been speakers at the dinner during the eight years the club has been functioning.

Josephine E. Hughston

Eight Straight Years

Shown at left in 1929, Rev. Thomas Landels organized the Los Altos Men's Club with 38 members in 1921. Supper meetings were held at his Union Church and later at Scout Hall. They featured "bountiful and satisfying" meals and drew many guests of distinction. The club also functioned as an unofficial chamber of commerce. Its peak of 90 members gradually fell during the Great Depression, and its civic work was taken over by service clubs after World War II.

The Los Altos Garden Club was founded by the Los Altos Men's Club, and this photograph shows Lena Shenk amid displays at its first exhibit, held in 1929 near the Shenk house. It quickly became a popular institution and brought the county flower show to town. Its programs always included contests designed to interest children in gardening. The club also did civic beautification work, like landscaping the railroad station. (Los Altos Garden Club Collection.)

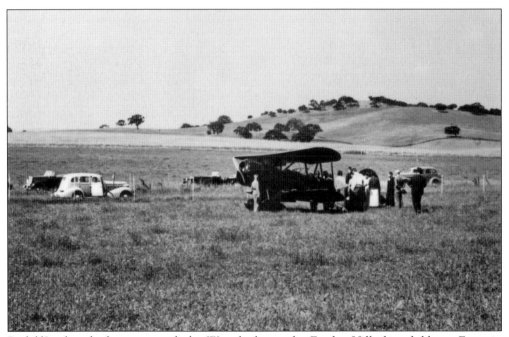

Rudolf Isenburg built an air strip for his Waco biplane in his Feather Hill wheat field near Fremont Road and Trace Lane. He is shown here with friends in a 1930s gathering.

Six

THE
GREAT DEPRESSION
YEARS

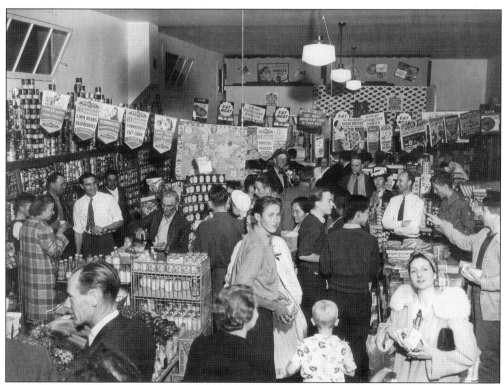

Perhaps because it was still largely agricultural, Los Altos was marginally less affected by the Great Depression than most American towns were. Annual bargain sales like this one at the J&S Market (on First and Main Streets) in 1940 were a popular feature of many stores during the Depression era.

Even as powerful an institution as the Southern Pacific Railroad felt the pinch during the Great Depression. Fewer passengers meant reduced revenue, which explains the advertisement at left. While not nearly the bargain it would be today, it represented an attractive fare reduction in 1931.

On its local route, Peninsular Railway traffic gradually fell off from its peak in 1915. Patronage was further reduced during the Depression, and the railroad applied to close its service. This was granted providing they substitute bus service along the same route. They complied, and in March 1933, the trolleys stopped running. Southern Pacific's steam service on the route continued daily, departing at 7:12 a.m. and returning at 6:20 p.m.

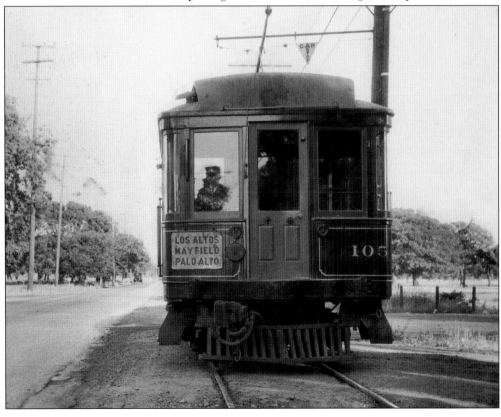

During the Depression years, men seeking work would "ride the rails"—hitching an illegal and often dangerous ride on a freight car. Located under railroad bridges near a town (where trains had to slow down), "hobo jungles" were places they could camp and exchange food, stories, and practical local advice. The Los Altos jungle was beneath the railroad trestle over Adobe Creek, near the site of this photograph. Parents would warn their children against going anywhere near it, but most housewives would provide a wandering hobo with a meal, whether or not he could pay for it with a chore.

Hobos were not the only ones to ride the rails. Some young men did it as a lark; locally, one of them was Alan Cranston. The future U.S. senator is shown at right as a high school graduate, after which he attended Pomona College for a year. Before going on to Stanford in 1931, he saw some of America from a freight car on a ride to New Orleans and back. Colin Peters had a similar adventure, taking a freight train east and back in the summer of 1942, before interrupting his Stanford studies to join the U.S. Navy.

Colin Peters, a son of pioneering Los Altos real estate agent Herman Peters, is pictured at left in the early 1930s with Asthma, his pet raccoon acquired during a trapping foray for coyote and fox pelts. One of his routes was to hike up to the hills surreptitiously through Toyon Ranch. Colin's later home in Los Altos Hills with its wide view of the valley was located on the exact spot he had discovered on one of these youthful trips.

George Neary bought 900 acres of hilly land in 1917, where Hale Creek began. He excavated an area, yielding rock until the quarry pit required constant pumping. In 1935, Sondroth Brothers took over the operation, producing aggregate of base rock quality, useful for driveways and city streets. Heavy truck traffic caused constant friction with neighbors until it closed in the 1960s. Los Altos Hills Measure B eventually allowed it to be developed as Quarry Hills, with 24 luxurious homes around the lake-filled pit.

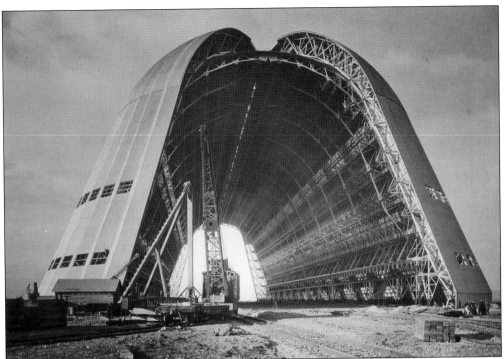

In 1930, the Los Altos Chamber of Commerce raised $1,500 as its share of Sunnyvale's successful campaign to buy agricultural land to be offered the U.S. Navy as an incentive to build their western airship base here instead of at a competing site. The resulting Sunnyvale Air Station was home base for the USS *Macon*. When it crashed in a storm off Big Sur in 1933, killing Adm. William Moffett, the field was renamed in his honor. (California Room, San Jose Public Library.)

This photograph of the Los Altos Library was taken in 1935. The library had moved into the vacated railroad power station after it was renovated with donated material and labor, plus WPA help. Its history began in 1914, when a local committee finally persuaded the county to establish a branch in the Altos Land Company building on Main Street with around 100 books. In 1922, it moved into the new Scout Hall with Jessie Landels as librarian. A new library building was built in the civic center after Los Altos incorporated in 1952. (Los Altos Garden Club Collection.)

Spartan Ramsey, George Ramsey's brother, bought the service station and general store and tavern at Loyola Corners, pictured here about 1935. Young people liked to hang out on a bench between the buildings, sometimes joined by those from the fancier country club homes on the other side of the tracks. Although as close to Mountain View, the Loyola Corners area became tied to Los Altos, perhaps owing to the direct rail link and as it was part of the Los Altos School District.

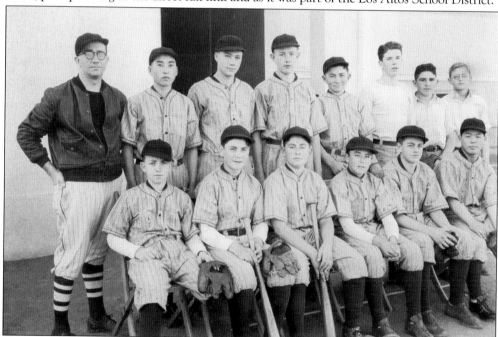

Here is the 1934 grammar school baseball team, coached by principal and teacher Matthew Thiltgen. The older schoolboys were given a talk in 1930 by Hall of Fame icon Ty Cobb, who by then had retired from playing baseball and was living in Menlo Park. He spoke about good sportsmanship—an unusual subject for a player of Cobb's famed aggressive, competitive intensity.

A young Larry Nelson arrived in 1934 with a pharmacy degree from UC Berkeley and bought the Los Altos Pharmacy. As a hobby, he joined the newly formed Community Players. While understudying Romeo and Juliet, he and the comely Beatrice Konrad fell in love. They enjoyed a happy 57-year marriage together as the family business grew. Larry built a new store at Second and Main Streets in 1940. Bart and Kent Nelson followed in their father's footsteps, and today the Los Altos Pharmacy is the oldest one-family-owned business in the city.

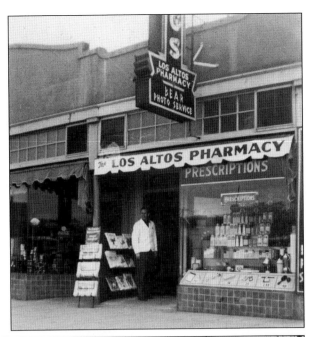

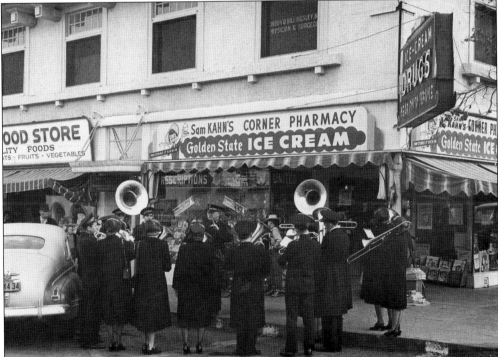

The Salvation Army Band was playing in front of the Kahn Pharmacy in this 1946 photograph. Sammy and Annette Kahn moved to Los Altos in the spring of 1939, enchanted with its small-town ambience, heightened by the profusion of spring blossoms. They bought the J&S drugstore and later built this store at Third and Main Streets. Despite working long hours, Sammy became involved in civic affairs, eventually becoming a 50-year Rotarian. He is remembered fondly by longtime residents for his special kindness and patience with them as children.

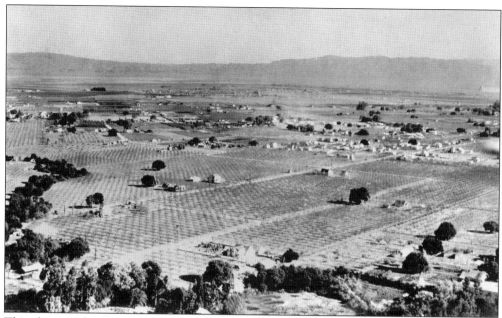

This photograph offers a dramatic view of how orchard-oriented the Los Altos area still was in 1935. Taken for the owners of a new house on Van Buren Street in the foreground, it ends on the right at Santa Rita Avenue. Parallel above it is Portola Avenue, with Dixon Way linking the two. The Moffett Field hangar is prominent in the distance. Adobe Creek is beneath the trees to the left, and to their left is Alta Vista Cemetery and Palo Alto.

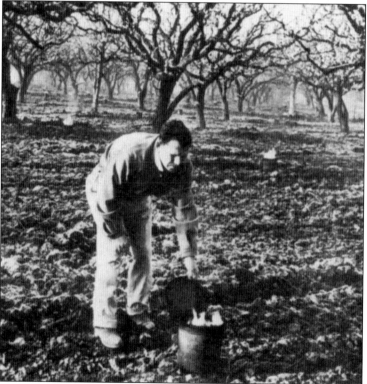

Smudge pots were widely used locally to produce enough smoke and heat to abate frost, saving fruit from freezing before the pits set. Saving farmers sleepless spring nights watching the thermometer when frost threatened, early radio frost reports gave advance warning if a critical point was reached—usually when the temperature reached 28 degrees for 28 minutes. Smudge pots passed out of use as a result of issues with air pollution. (*San Jose Mercury News*.)

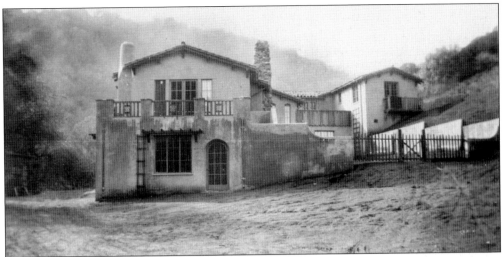

Frank and Josephine Duveneck bought Hidden Villa on Moody Road in 1924 and grew it into a 1,600-acre ranch. They built this home in 1930 near the old farmhouse and decorated it with artwork by Frank Duveneck Sr. In 1937, they opened the first youth hostel in the West and started the Fiesta Horse Show. They embraced liberal causes, such as the Fair Play Committee, and their friends included Diego Rivera, who dined there in 1931. In 1945, they started the first multiracial summer camp program in the United States. Their children donated Windmill Pasture to the Midpeninsula Regional Open Space District in 1977. Hidden Villa continues to advance the Duvenecks' dream of preserving the watershed while providing a hands-on educational experience in organic farming for children of all races and backgrounds. (Elizabeth Dana Collection.)

Milton Haas had Italian stonemasons build this English Tudor–style mansion on his "gentleman's country estate" in 1934, and its 35-acre grounds were carefully landscaped with rare foliage. He sold it to Henry Waxman in 1945, who bought more land for a swimming club, which became Adobe Creek Lodge. He added a supper club for 500 guests and other facilities, making it a venue for dance bands like Jimmy Dorsey. Eventually the lodge occupied 100 acres, with parking for 2,000 cars and barbecue facilities for 7,000. Neighbors constantly resented its noise and traffic, and it became a private country club in 1961. It was eventually closed, and only 6 acres of the original Haas estate remain, surrounding his house.

Secured by brick posts, this decorative iron gate crafted by Los Altan Herman Bleibler originally stood at the entrance to Sun Acres, the 1932 two-story, 10-room country home of Henry D. Collier. As a vice president of ARAMCO (a Standard Oil of California subsidiary), he was involved with their Saudi oil explorations. The home and its extensive gardens were accessed from Los Altos Avenue, and they now lie between Stratford Place and Bridgton Court. (Lisa Robinson.)

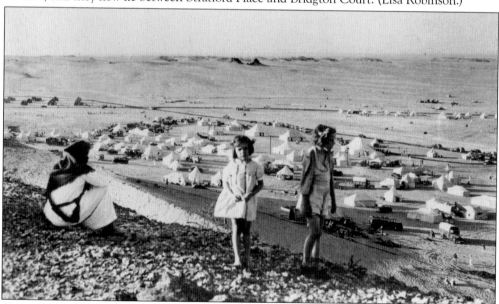

This 1939 photograph shows Maxine and Marian Steineke overlooking King Ibn Saud's huge encampment at Dhahran, Saudi Arabia. At the time, Saud was visiting the remote ARAMCO enclave near their recent oil discoveries, which soon changed Middle East history. Much of ARAMCO's success was due to Max Steineke, its chief geologist, who had brought his wife, Florence, and their daughters to the small American enclave in 1938. When war threatened, they returned to Los Altos, buying the Purissima Drive home of her parents, who had recently died.

Seven

THE LOCAL HOME FRONT
IN WORLD WAR II

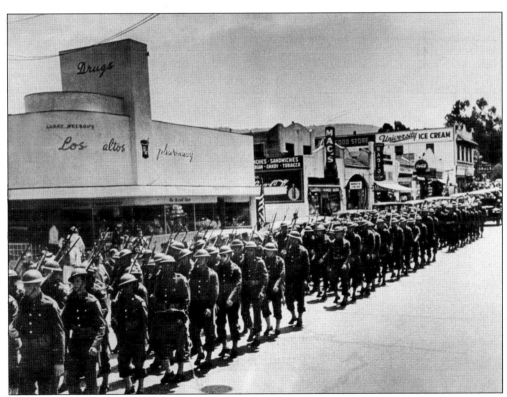

This photograph of marching soldiers wearing World War I helmets shows how early in World War II this Los Altos parade took place. Usually designed to help sell war bonds, such events were publicized with colorful government posters and were well supported by local organizations. Los Altos was proud of its record of always meeting its assigned quota. The Main Street of 1942 still looks familiar today, although some facades and business names have changed.

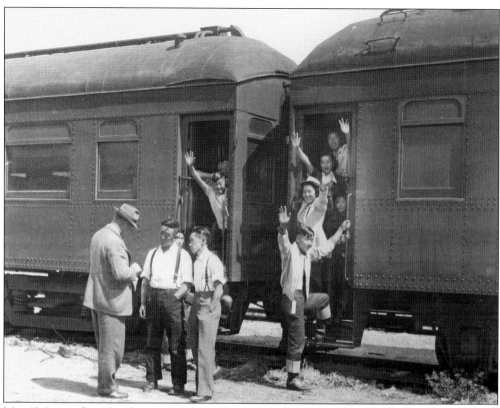

May 1942 was a heartbreaking time in Los Altos. Nearly 10 percent of its population was naturalized or second-generation Japanese Americans, and suddenly all who were not already in the military were sent to a relocation camp at Heart Mountain, Wyoming, with only what they could carry. This photograph shows the scene at the local train station at the time. Some Los Altans tried unsuccessfully to shield their Japanese American friends from Executive Order 9066 but were at least helpful in protecting the internees' interests when they were gone. (*Los Altos Town Crier.*)

After his army service, amateur historian Joe Salameda moved to Los Altos and began interviewing its pioneer residents. He formed the Los Altos Historical Association in 1957, which in 1977 was given the responsibility of running the Los Altos History House Museum and its many volunteers in the old Gilbert Smith house. This task was further enlarged when the new history museum building opened in 2001. His work resulted in *Memories of Los Altos*, published in 1982.

Plans Completed For Black-Outs In This Vicinity

Black out signals are the most important topics of conversation in Los Altos today.

Several air raid alarms, three of them Tuesday night, have been sounded and have been met with calmness and co-operation on the part of our citizens.

Losing no time, representative citizens on Tuesday afternoon met with representatives of the telephone, water, lighting utilities and other authorities.

The *Los Altos News*, being a weekly, did not have the dramatic Pearl Harbor headlines seen in the city dailies. But as shown here, its issue only four days later highlighted immediate blackout plans against possible air raids. The government urged communities to make contingency plans. Local blackouts were enforced by neighborhood air raid wardens, and plans were made to turn a church into a hospital. For a coast-wide aircraft warning system, local volunteers manned an observation tower on San Antonio Road, taking four-hour shifts to telephone Moffett Field about the types and headings of all aircraft spotted.

Contingency plans included providing for the safety of schoolchildren during an air raid. Los Altos Grammar School children were assigned "safe spots," such as in nearby homes with basements. Some children were sent next door to the Gilbert Smith orchard (pictured here), where they could huddle under the apricot trees. Emergency drills were held periodically to facilitate action should a real air raid ever actually take place.

TWO LOCAL MEN ARE HEROES OF DARING ESCAPE FROM BATAAN IN PACIFIC WAR

Capt. Charles R. Sneed, husband of Lily Koch Sneed of Los Altos, and Lt. Parry L. Franks, also husband of a Los Altos resident, last month distinguished themselves as the heroes of one of the most spectacular escape dramas to come out of the Pacific war.

A few days after the fall of Bataan, Capt. Sneed, Lt. Franks, and an Associated Press correspondent successfully eluded Japanese forces surrounding Corregidor fortress and took off from a secret airfield in an old two-seater biplane trainer of the Philippine army.

The *Los Altos News* published stories like this in response to the strong desire for news of local men in the services. For graphic films of the war, newsreels were popular, and although there was no local theater to show them at that time, they could be seen at Palo Alto and Mountain View theaters.

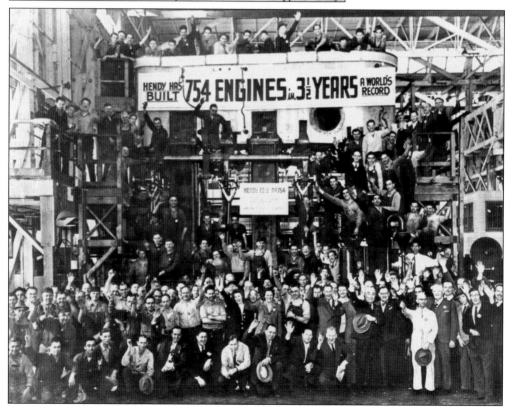

Any resident who could worked for a wartime factory—generally Los Altos housewives and older men. The nearest such factory was the Joshua Hendy Iron Works in Sunnyvale. It made marine engines, and this photograph depicts a world-record celebration after manufacturing marine engine number 754. Hendy's eventually became a Northrop Grumman Marine Systems plant, but its history dating to the Gold Rush survives in the Iron Man Museum located there. (Iron Man Museum, Sunnyvale.)

Many Los Altans worked in Cupertino for the Kaiser-Permanente Company, which took over an existing Cupertino limestone quarry in 1939. It became the world's largest concrete plant, producing material for construction of the Shasta Dam. The plant was enlarged under U.S. Army contracts in 1941 to provide magnesium for airplane parts, tracer bullets, and incendiary bomb casings. It operates as Lehigh Permanente Cement (since 2007).

Within Los Altos, two small enterprises did their World War II bit by filling U.S. Navy contracts. The Formway Machine Shop off Almond Avenue, shown here, initially serviced Ford Model T automobiles and later invented and produced their successful Wizard Walnut Huller. Formway got a navy contract to fabricate small items for submarines. Retired ironworker Herman Bleibler got a navy contract to resharpen shipyard chipping hammers. He did this work on a small forge he had built behind his home.

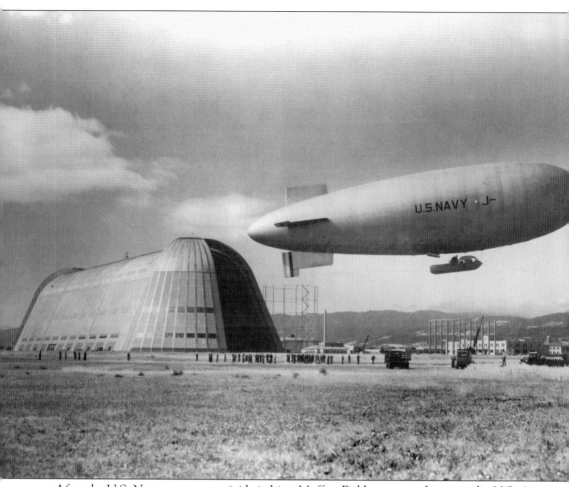

After the U.S. Navy gave up on rigid airships, Moffett Field was turned over to the U.S. Army Air Corps. Soon after Pearl Harbor, the navy reclaimed the field and used it for a patrol base to guard against possible Japanese incursions. They used balloons for training and blimps such as the early model pictured here for patrol operations into the Pacific. This wartime role brought in many additional navy men, and nearby Los Altos helped provide additional recreational diversion and off-base living facilities. (Moffett Field Museum.)

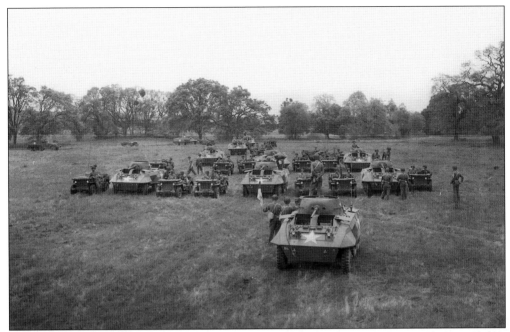

The 107th Cavalry's Troop A reconnaissance squadron was stationed at Page Mill Camp in late 1944 when this photograph was taken. It was an element guarding the West Coast against possible Japanese incursions. The troop's commanding officer once phoned the Filoli Estate for permission to bivouac his 170 men there during an exercise. Visions of 170 horses went through Lurline Roth's head, and she hesitated before apologetically telling Lt. Leslie M. Westfall she was sorry but the town of Woodside strictly limited Filoli to six horses. She was greatly relieved to learn that the army's cavalry had been mechanized in 1940, and the bivouac went on as planned.

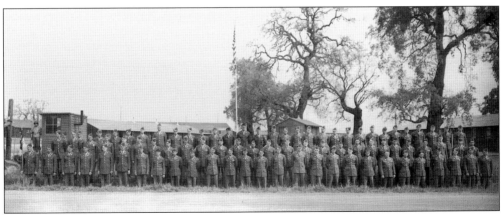

Early in 1942, Stanford University provided land to the U.S. Army at the corner of Page Mill and Junipero Serra Roads, and an advance training camp was quickly erected, complete with barracks and firing range. Page Mill Camp soon opened for the 125th Infantry Regiment. The Los Altos PTA organized a "hospitality group" to provide recreation for its soldiers, sending carefully chaperoned young ladies to camp dances on army buses and organizing dances at the San Antonio Club. Pictured here is the 107th Cavalry Troop A in late 1944.

Early in World War II, soldiers from Page Mill Camp came to the Los Altos Grammar School to give an exhibition. This photograph shows the entire student body lined up outside for the event.

Pretending to fire a machine gun was the most popular display at the Page Mill unit's demonstration for the boys and girls of the Los Altos Grammar School.

Page Mill Camp's firing range targets faced southeast, against hills beyond Matadero Creek; this happened to be the direction toward downtown Los Altos. As the *Los Altos News* headline at right announced on April 27, 1944, an errant shell [misspelled as "shall" in the article] poked a hole in the roof of the Vinette Elber Ruble house on Second Street (the former Eschenbreucher home), damaging some plaster and wires in the attic. The camp sent a repair team out to repair the damage, and it was reported that Mrs. Ruble gave the boys several home-cooked meals.

LOS ALTOS HOME IS HIT BY ERRANT SHELL

Los Altos may be a long way from the fighting fronts, but for one of this community's families it seemed very close to the battle fields last week.

Members of the V. E. Ruble home on Second Street escaped possible disaster one day last week when, according to their report, a large shall, projected from an army field, pierced the roof of their house and shattered the plaster in several rooms.

An officer of the field, upon being notified, came to the scene, and, the tale goes, was at a loss to account for the mishap, since the guns were not pointed in this direction.

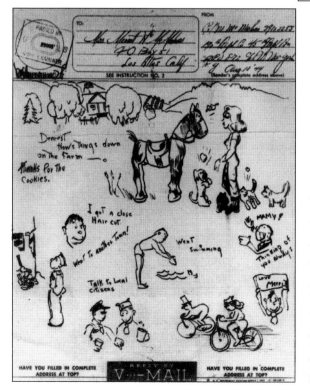

To save airmail weight, the U.S. Post Office instituted V-Mail in 1944. These small forms were used for letters to and from servicemen overseas. Merritt McMahon was an artist whose father owned Mac's Tea Room, and as a GI, he saw action on D-Day and in the Battle of the Bulge. His beautiful drawings and humorous cartoons illustrated the many V-Mail letters he sent to his wife, Ruth. This example was one sent in 1944 from England. (Ruth McMahon.)

GOLD STARS
ON THE LOS ALTOS
ROLL OF HONOR

Louis Eugene Andriano
Nick Balliff
John Blair Beach
Byron Bennett
Edward Nelson Bewley
Ted Bower
Julian Burnette
Leon Claverie
Frederick Bronson Cooley
George Phillips Davis
Morian Deal
Philip Doty
Bernardo Xavier Ferrari
Paul Fretz Sr.
William Gunther
Charles B. Gurrier
William Henry Losse
Charles Mardel Jr.
Richard Hunter McClure
Forest S. O'Brian
George O'Brien
Melvin O'Connell
George Arthur Osen
Harold Piggott
Mark L. Smith
Charles Roy Sneed
James F. Taylor
Howard Clinton Weller

The *Los Altos News* named 241 local men who joined the U.S. Army, Navy, Marine Corps, Coast Guard, and Merchant Marine during the war, although the actual total was probably nearer 400. Early in 1946, the paper printed this memorial tribute to honor the supreme sacrifice made by 30 local families.

During the war, local drives were launched to sell defense stamps and bonds, to raise money for the USO and Red Cross (whose overseas programs included sending food to American POWs), and sending garments to Philippine Relief. Other local relief efforts included Hidden Villa's Garden Show for Russian Relief, the Shoups' "China Relief" gala, the Christian Science Church War Relief Committee's efforts "for liberated people," and a British War Orphan Relief program.

LOS ALTOS, CALIFORNIA, THURSDAY, JANUARY 29, 1942 NUMBER 27

Paper Drive Closes Friday

The Boys Scouts are going to close their paper drive on Friday, January 30. L. W. Williford, committee chairman, has arranged to dispose of all accumulated paper the following day.

Any citizen whose pile of newspapers has been overlooked, may call Los Altos 4456.

The boys have collected approximately three tons of paper to date.

Plans For Canteen Kitchen Unit Completed

Many individuals, perhaps, do not realize the full extent or real nature of the canteen branch of the Red Cross, whose endeavors are not confined to disaster alone but also to feed properly any defense groups that happen to be quartered temporarily or who may be passing through the community. State guardsmen, Boy Scouts,

PROF. BECK IS SPEAKER AT KIWANIS CLUB

A Stanford visiting professor, N. B. Beck, who hails from the University of Hawaii, addressing the Palo Alto Kiwanis club last week made some statements that may or may not be startling to this community.

Prof. Beck declared that at the present moment the coast of California is more vulnerable than Hawaii, which he says is now thoroughly awake, whereas here, the feeling was that "it couldn't happen to us."

The speaker cited the decrease of civilian defense vigilance on this coast since the first flurry of enthusiasm last December. Even in the islands, he stated, while there was a great rush due to enrollment for voluntary defense work immediately after the Pearl Harbor catastrophe, there has been quite a slackening since.

He also stated that although one-third of the civilian population of Hawaii is Japanese, he believes the great majority of them are loyal to the United States.

CHARLES SPINKS HEADS LOS ALTOS DEFENSE STAMP AND BOND DRIVE CAMPAIGN

"Keep 'em Buying, to Keep 'em Flying, Rolling and Sailing; Defense Stamps and Bonds Are Needed to Do the Job."

That is the message from Uncle Sam to all inhabitants of the United States. A meeting of citizens called last Friday by Charles H. Spinks, at the request of the United States government, was held in the school building.

Merchants' Ass'n Gives $20 To L. A. Medical Unit

The Los Altos medical and emergency committee is $20 richer because of the donation of that amount by the Merchants' association at its annual meeting held last week.

"Stamps and bonds are going steadily and strong," that letter declared, "but the pace must not slow up."

Tanks, airplanes and submarines, tiny and huge; ships of the line, transports, merchantmen, tankers, carriers, barracks and guns, rifles, hand grenades, food, uniforms, artillery, machine guns, hospitals.

Money is what it takes to keep a war going. Why not loan our nation the cash to help keep them

Based on the number of ration books officially distributed in 1944, it was reported that the population was 3,551 for the "Los Altos area." What that area covered is uncertain. It may have been that used by Santa Clara County in its voting register, or by the post office, or by the 1940 census. Whatever area was covered, it is likely to have been somewhat less than that of today's Los Altos and Los Altos Hills.

57 2 224 L

4

UNITED STATES OF AMERICA
OFFICE OF PRICE ADMINISTRATION

WAR RATION BOOK FOUR

Issued to ___Norman___ ___Ansley___
(Print first, middle, and last names)

Complete address ___Main St___ ___P. O. B.___ ___303___

___Los Altos, Calif___

READ BEFORE SIGNING

In accepting this book, I recognize that it remains the property of the United States Government. I will use it only in the manner and for the purposes authorized by the Office of Price Administration.

Void if Altered *Norman Ansley*
 (Signature)

It is a criminal offense to violate rationing regulations.

OPA Form R-145 16—35570-1

COT CUTTERS ARE URGENTLY NEEDED HERE

Apricot cutters are desperately needed by the valley's ranchers, and the need must be met immediately if the heavy crop is to be saved this year. Persons who are willing to do their part and back up the war effort by providing food for the servicemen on the battle fronts may contact the Farm Labor office in Mountain View at Mountain View 2364.

PRUNE WORKERS NEEDED LOCALLY

Families and children who can work in the prunes are urged to contact the Mountain View Farm Labor office at Mountain View 2364. This weeks marks the beginning of the month-long prune harvest and many orchards in this locality will need volunteer help.

"Small farms will need workers particularly," the labor office reported, "so that children should signify their willingness to gather the fruit by calling our Mountain View office."

Wartime shortages led to various drives, reflected in these *Los Altos News* headlines: December 1941: "Boy Scouts Sponsor Paper Drive for Defense"; April 1942: "Save a Life—Give Your Blood"; August 1942: "Junk Needed for War—Local Scrap Drive Getting Underway"; October 1942: "Gas Rationing Sign-up To Be Held At Schools"; January 1943: "Tin Cans May Be Brought To Groceries"; "Important Rationing Information" (about coffee, sugar, cheese, meat, fats, oils, shoes, gas, tires, and so forth). With so many men gone, headlines also told of needs for harvest workers: August 1943: "Recruiting of Women to Work In Canneries And Harvest Is Current Project of Local PTA"; "Scouts Harvest For Victory"; December 1944: "Labor Board Still Seeking Pruners"; July 1945: "Cannery Help Need Still Urgent."

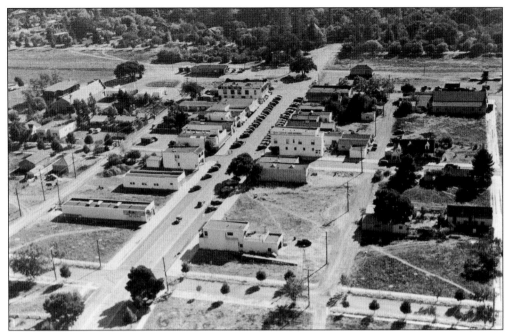

This is how downtown Los Altos looked from a U.S. Navy blimp in 1944. In the lower right is the intersection of Main Street (heading diagonally up to the right) and Third Street (across the bottom). The oak tree on Main Street just beyond First Street can be seen in the upper middle, with the passenger depot on the left and freight depot on the right.

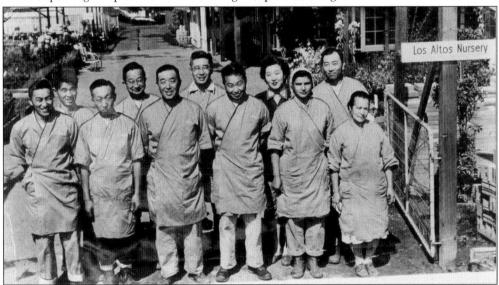

Many Los Altos citizens protected the chattels and real property of their Japanese friends. When the internees were able to return home, friends formed the Fair Play Committee to help them resettle. Because they were still sometimes faced with prejudice, the committee also gave them legal and other assistance in buying and renting. The Furuichi family, farming here since 1919, was a relocation success story. In 1946, they established the Los Altos Nursery, whose workers are shown above. As a gesture of thanks, they furnished the Chinese Pistache trees that the city planted to ornament downtown streets in 1954.

Eight

THE POSTWAR
POPULATION EXPLOSION

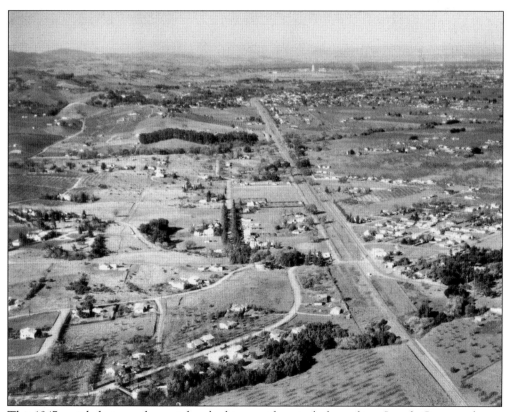

This 1947 aerial photograph was taken looking northwesterly from above Loyola Corners, shown in the right foreground, where Fremont Avenue turns to the west across Permanente Creek. The southern Los Altos area was still largely agricultural, and few houses had been built in the country club land in the left foreground. The railroad line disappears in the distance where Stanford's Hoover Tower is faintly visible.

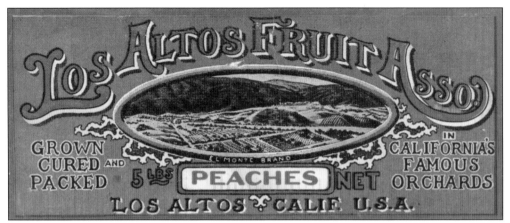

Fruit box labels like this were well known to Los Altos orchardists. While different types of fruit were grown here as cash crops, they were processed by companies in Mountain View or Sunnyvale. Peaches, shown on this label, were a minor crop within the Los Altos area. The postwar rush to subdivide agricultural lands to provide new homes gradually made these labels merely historical artifacts.

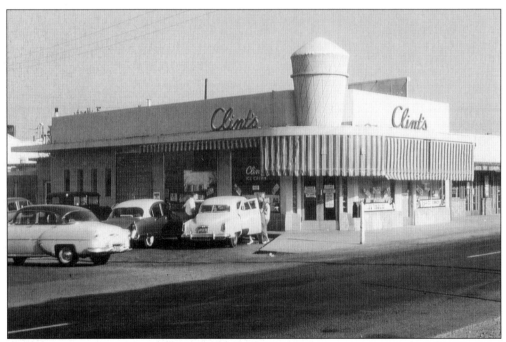

Oral histories collected by volunteers at the Los Altos History Museum rarely fail to mention Clint's Ice Cream store as a favorite hangout spot for adults as well as for kids after school. Clifton Roe opened the store in 1946; because he made delicious ice cream, his business thrived. The ice cream cone built on top of the store survived after Roe sold his store in the 1970s, and it was repainted; currently the building houses a hardware store.

Al Galedrige opened Al's Barber Shop in 1948. He introduced a popular program of photographing the before-and-after views of each child's first haircut, like this one of Rocky Sherman. Al later faulted the long-haired Beatles for a long period of slow business. Prior to World War II, Joe Zingarelli was the town's first barber, and his shop on State Street had a pool table inside for customers to use while they were waiting.

The Los Altos Community Foundation rescued two historically important Los Altos houses, moving them to Hillview Avenue. The DeMartini home now functions as Community House. Built by internationally renowned architect Richard Neutra on Marvin Avenue in 1939, the second is Neutra House. Pictured here with its first owner, Jacqueline Johnson, it was one of a set of three small houses surrounded by orchards and exemplified the California modern aesthetic of indoor-outdoor living. (Los Altos Community Foundation.)

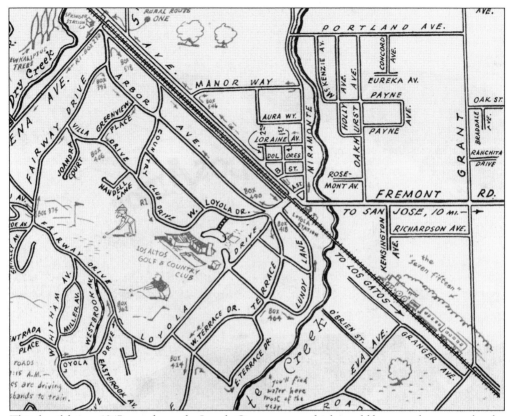

This detail from a 1947 map shows the Loyola Corners area, which would become the eastern border of Los Altos upon its incorporation five years later. The map was made by David MacKenzie and Warren Goodrich, who also founded the *Los Altos Town Crier* in 1947. Goodrich, a professional cartoonist, furnished illustrations, including the logo of a town crier with his bell, still in use. MacKenzie added humorous touches. Begun as an advertising circular, it gradually increased in size, local news coverage, and quality of paper and photographs. It became the only local weekly when the *Los Altos News* ceased publication.

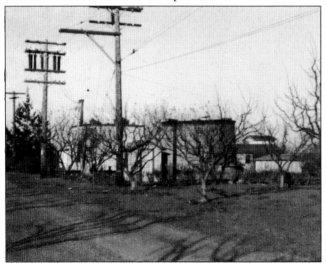

The Los Altos Park area was served by the Spinks Water Company, whose storage tanks, viewed here from San Antonio Road, still stand on Pleasant Way. In 1931, the California Water Services Company took it over, and it still serves the City of Los Altos. (Los Altos Hills gets its water from the Purissima Water District.) The Hetch-Hetchy pipeline right-of-way through northwest Los Altos was converted to a paved pedestrian and bike path to Arastradero Road in Palo Alto.

This c. 1949 photograph shows an area eventually overtaken by Foothill College and I-280. The view is due east from a point above today's Elena Road and Becky Lane. The most prominent road, running from the lower right up to the left, is El Monte Road.

After World War II, some county zoning changes made against nearby residents' wishes changed part of Horace Hill's ranch from residential to commercial use. One part became Pink Horse Ranch, shown here on a typical summer day in the early 1950s, when it drew thousands of day-trippers to picnic, swim, dance, or attend horse shows and theatrical events. Inevitably, it brought traffic and noise, which drew enough neighboring resentment to eventually cause its demise.

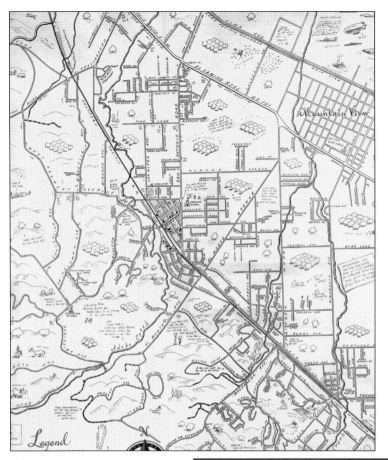

A 1936 chamber of commerce article in the *Los Altos Times* indicated that the Los Altos community was generally defined as persons living within 1½ miles of the railroad station in all directions. This 1947 real estate promotion map, like all previous maps, shows no distinction between the areas that would legally evolve into the twin towns of Los Altos and Los Altos Hills in 1952 and 1956. (Los Altos Chamber of Commerce.)

The Altos Theater opened in May 1949. It was built along art deco lines, but its interior had some touches of earlier, ornate movie palaces. The Eckles-designed murals were based on Greek myths and rendered in subtle shades of green. All 545 comfortable "push-back" seats were filled on opening night, reported as having "all of the trimmings of a Hollywood First Night, with searchlights, gardenias for the ladies, speeches and crowds of onlookers." It eventually succumbed to competition from television in 1975, and when efforts to save it failed, it was converted into an office building.

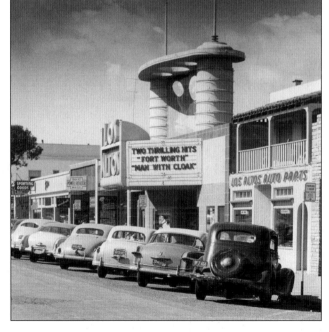

Since the 1930s, the Los Altos Grammar School held a "Play Day" on May Day. This evolved to include a parade, for which students would dress in humorous costumes. In the 1946 parade, the prize winners pictured here were, from left to right, Ralph Appio, Bob D'Armond, Richard Risso, Waldo Griffith, and Ronnie Warren.

This is the home in the hills where Pres. Ulysses S. Grant's oldest son, Jessie Root Grant, spent his last years. (Los Altos Hills Historical Society.)

Between 1947 and 1949, the Los Altos area population increased an average of 25 percent annually. This huge postwar increase of families created an enormous problem for the Los Altos School Board. By September 1949, students in grades one to eight had increased 123 percent, and the many very young families made the increase of kindergarten students even greater. Temporarily, it was necessary to institute double sessions. With a parcel tax increase, plus county and state emergency building funds, Hillview (shown above), Loyola, and Portola Schools were constructed, opening in September 1949.

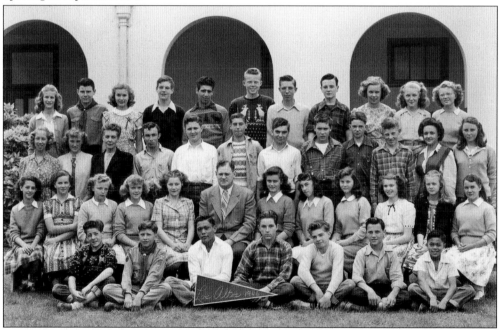

Ardis Egan is surrounded by his eighth-grade students in this photograph of the Los Altos Grammar School class of 1946. Egan was also the school's principal at the time but was soon promoted to superintendent. He served effectively during the difficult years when new schools were desperately needed. He began planning for a Los Altos High School, which was eventually built in 1957. To honor his memory, the school district changed San Antonio School's name to Egan Junior High School in 1964.

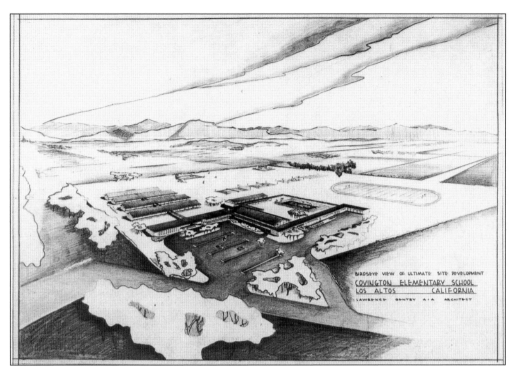

Lawrence Gentry served as the school board's architect for most of the new schools hurriedly built after World War II. The architectural drawing for his Covington School is shown here. Before World War II, Gentry had been active in community affairs, being one of the local Rotary founders. He also headed the Los Altos Business Association in 1946.

Lucille Liewer is pictured here with a Community Service Award given by the Los Altos Board of Realtors. Her long civic service began when she was volunteered by her son to join the Hillview PTA in 1949. She became deeply involved in it and then became a dynamic presence on the Los Altos School Board, serving from 1954 to 1961. She finished up her work with the schools by again serving as a PTA president in 1964. Her son later became assistant superintendent. (Dick Liewer.)

Westwind Barn had six stalls when it was built in the mid-1940s by Frank Ellithorpe on 30 acres. Seventeen more stalls were added by Robert Clement in 1965. In 1971, Countess Margit Bessenyey bought it, naming it Westwind Hungarian Horse Farm, an extension of her Montana stud farm. She added a third wing and many elegant touches, a full-sized dressage ring and a difficult cross-country course. Later the Town of Los Altos Hills acquired the property and leased it to Friends of Westwind, Inc. In 1977, they set up a volunteer-staffed cooperative, whose many successful horse-related activities and programs make Westwind Barn a major community asset.

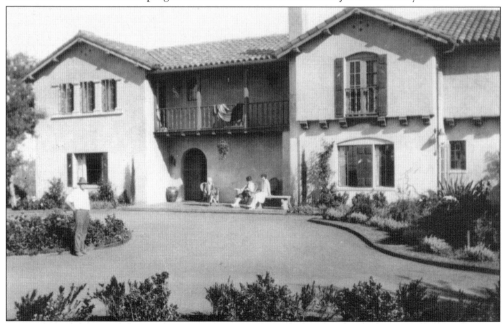

Arthur and Mary Fowle moved to the hills area in 1925 and built a ranch, La Esperanza. Arthur was noted for helping solve local problems directly with a personal check. He wrote one for $15,000 to make up the balance needed by the new City of Los Altos to buy the Gilbert Smith property. In 1956, he was elected the first mayor of Los Altos Hills, but he was too ill to take the post, unfortunately, and his son John Fowle was appointed to take his place on town council.

In 1949, Southern Pacific brought Los Altos special freight that only a railroad could then deliver—a major circus. The Yankee-Paterson Circus arrived in its own railroad cars and erected its tents in the fields east of the passenger depot. This sole major Los Altos circus appearance was organized by the Los Altos Chamber of Commerce to raise funds for the Los Altos Youth Center.

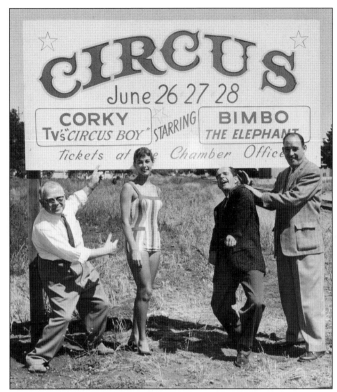

The first Thanksgiving Festival of Lights was set up by the Los Altos Village Association in 1977 and immediately became an annual classic event. However, it had a precursor in 1939 when downtown merchants raised $100 for Christmas lights, and the volunteer fire department strung them on the big oak tree at Main and First Streets, shown in this photograph. The *Los Altos News* reported that it "made a handsome sight."

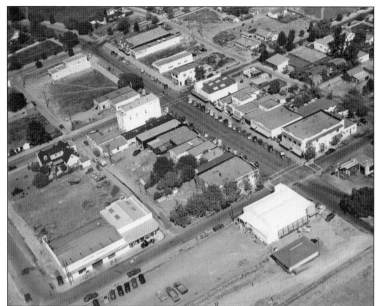

This aerial photograph was taken in late 1947 or early 1948 when the postwar building boom was just getting started. Gordon's Grocery can be seen in front of the oak tree at the corner of Main and First Streets.

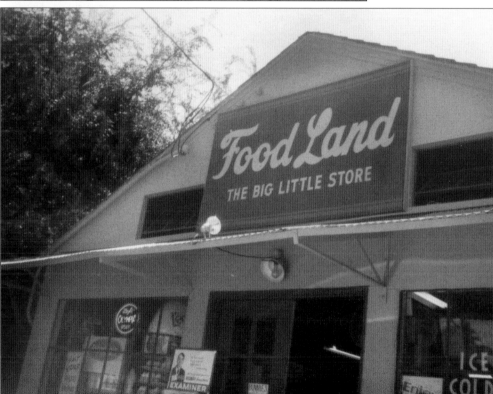

In 1941, George and Eleanor Mundinger built this small mom-and-pop store in front of their house on Santa Rita Avenue (now Los Altos Avenue). George, whose business was trucking produce into San Francisco, handled the stock, and Eleanor was the clerk and bookkeeper. They sold it in 1951, and in successive years, it had a number of owners, who usually changed the store's name. Substantially remodeled in 2009, it reopened as the neighborhood Sweet Shop.

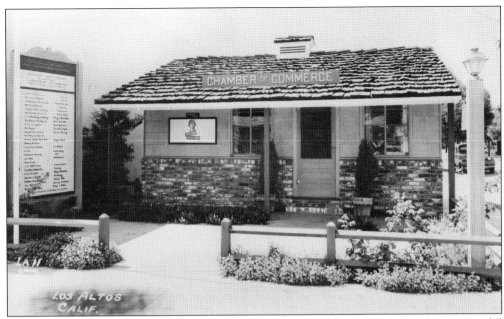

Even as an unchartered organization in the 1930s, the Los Altos Chamber of Commerce did much for the town, such as supporting the volunteer fire department. It was incorporated in 1951 and from the building shown here worked hard to improve the retail climate within Los Altos. It strongly supported converting the downtown alleys into parking plazas for 1,000 cars in 1958. In 1961, Goodrich Steinberg designed its new building, which has been much acclaimed for its harmonious beauty.

Billy Russell and Jack Huston were childhood friends from small towns in Iowa and later linked in marriage when Jack's brother married Billy's sister-in-law. After World War II army service, they decided to launch the first local menswear store in Los Altos. They opened in 1949 at 358 State Street with an exclusive line of clothing. By hard work stressing personal service, they succeeded in becoming the largest such store on the peninsula. They retired and sold the store in 1983.

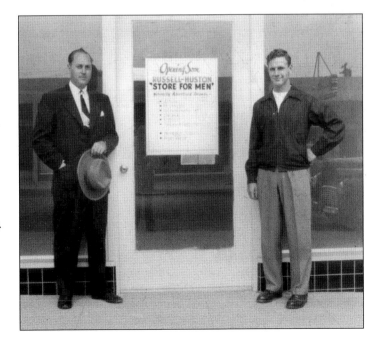

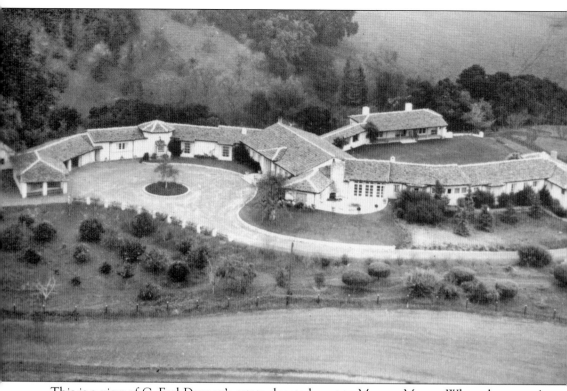

This is a view of C. Earl Dawson's estate, located next to Morgan Manor. When the manor's owners, Gerald and Gypsy Buys, were unable to get a liquor license, they decided to sell in 1947. Possibly as a ploy for publicity and a better sale price, they made it known they were negotiating with a "negro cult"—either with Father Divine or his New York City rival, Harry Brown. Dawson and others were incensed and raised $90,000 in a futile effort to buy the place. The Fair Play Committee, supporting the legal rights of minorities, gave a public lecture on "Race and Real Estate in Your Community." The race issue disappeared when the manor was bought in 1952 by the Ford Country Day School.

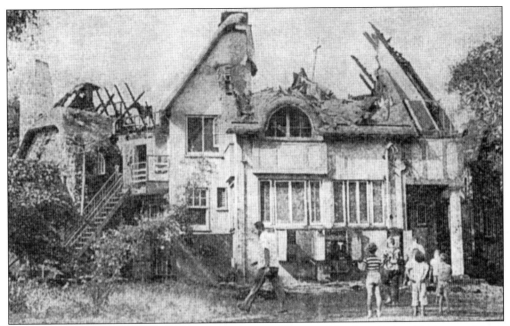

Christian Science Church members bought Twelveacres Estate and developed it into Twelveacres Home for Children. It also ran a popular summer camp program open to all. This newspaper photograph shows the mansion after fire destroyed it in 1960, and a few years later, the home moved to San Jose. The estate was then turned into an upscale subdivision around Twelve Acres Drive.

Joseph and Eugenia Andriano bought a fruit orchard about 1½ miles up Arastradero Road from the Alta Vista railroad stop. They planted a vineyard, and after his death and the repeal of Prohibition, the newly named Eugenia Andriano Winery proved to be quite successful. Because it was near the Poor Clare's retreat, the sisters' sign was often used as the landmark to find the winery, which was eventually displaced by the I-280 freeway.

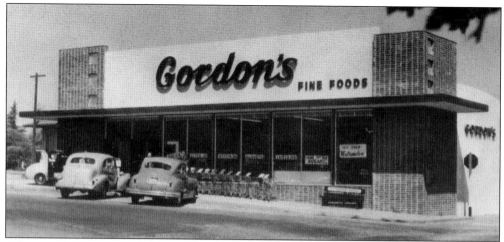

When it opened in January 1948, Gordon's Grocery was the largest market in town. Others were soon to follow—Safeway, Haskell's, Foodliner, White Cliff, and the Village at Loyola Corners. One thing all downtown and Loyola Corners merchants would soon have in common was opposition to the competition inherent in plans for the Rancho Shopping Center. Despite such resistance, the center opened in 1951 with 30 shops.

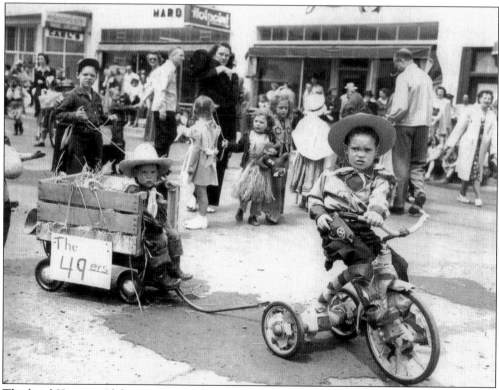

The local Kiwanis Club was organized in 1947. They sponsored Boy Scout Troop No. 27, and together they established the city's first Pet Parade on May 1, 1948. It quickly became an annual classic. In this photograph taken in 1949, the pharmacist's sons Bart and Kent Nelson are shown. The club went on to finance other programs, such as one for physically handicapped children. One of their fund-raising activities is their annual Christmas tree lot.

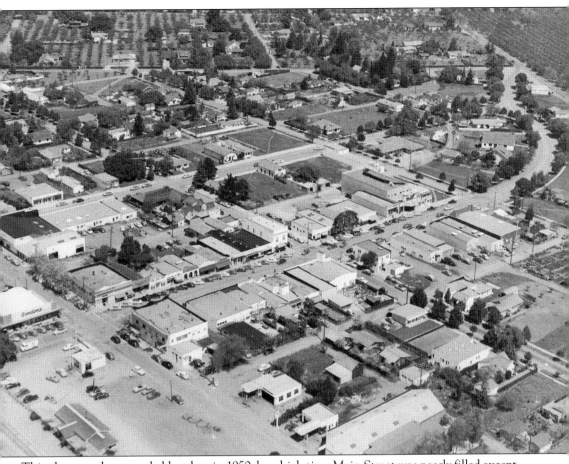

This photograph was probably taken in 1950, by which time Main Street was nearly filled except at the Third Street end. State Street was still sparsely settled. Gordon's Grocery can be seen at the lower left.

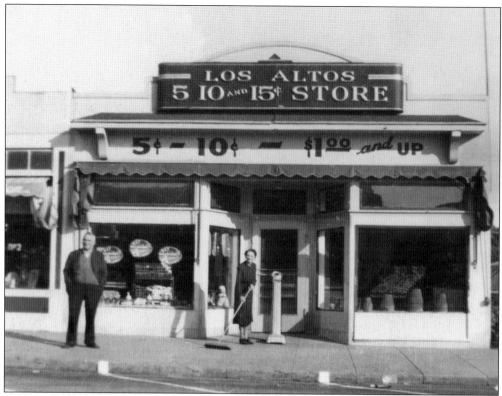

This Los Altos 5-10-15¢ store was built in the late 1940s on Main Street, replacing Stringers Place, a pool hall. The proprietors were Leandro and Elsie Lewis. Mrs. Lewis is sweeping; the man is unidentified.

This 1960 photograph shows John Lyon with his children by their plane. It was the central feature of the Lyon's J&J Air Rancho, located north of St. Joseph Road and parallel to the railroad tracks. The Lyons bought this land in 1947 and secured a county permit for a private air strip with an L-shaped house and hangar at its south end. John, a World War II pilot, managed the Santa Clara Valley Airport. Private flying gradually became less pleasant in the area, with increased nearby housing and air traffic. They sold the land in 1975 for a subdivision.

Paul Shoup, the "Father of Los Altos," died August 1, 1946, in Los Angeles. A memorial service for him was given at Stanford University a short time later. As he climbed Southern Pacific's ranks to become its president in 1929, he mostly lived elsewhere after 1913. But he often visited his wife, Rose, in their home at 500 University Avenue and fully appreciated the strong growth of the Los Altos he did so much to create.

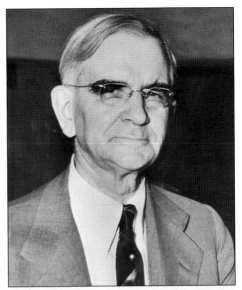

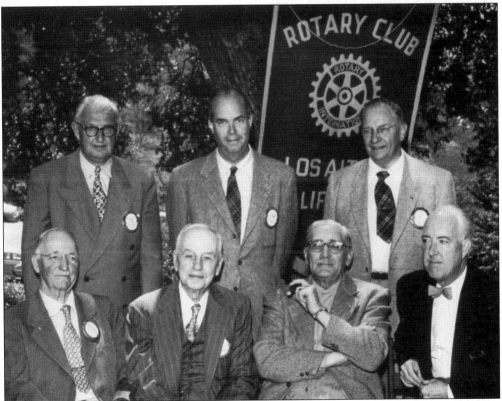

The founding president of the Los Altos Rotary Club, chartered here on May 5, 1949, was Paul's brother, Guy Shoup (seated, second from left). The organization follows the Rotary Club tradition of being dedicated to civic betterment. For example, it conceived and raised money for the Community Plaza, an outdoor civic forum at the junction of Main and State Streets. To raise funds, it sponsors such projects as Art in the Park, which graces Lincoln Park every May, and Ye Olde Towne Band, which gives summer concerts.

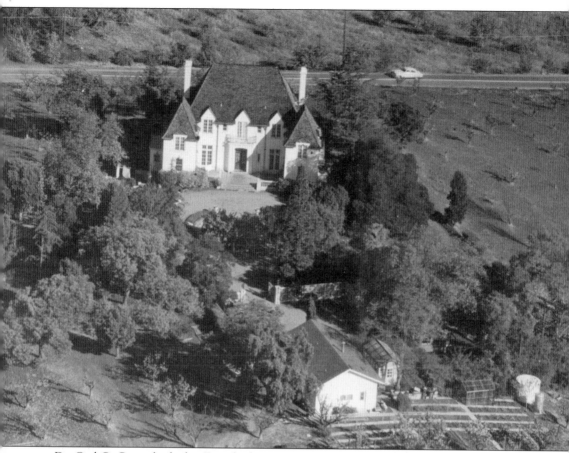

Dr. Carl C. Crane built this French chateau in 1922. In 1946, it was bought by Don and Mary Winbigler. Their estate became a favorite spot for artists, with its spectacular setting amid flowering apricot and plum blossoms. A dead apricot tree of theirs on Fremont Roads had a fancy resemblance to a reindeer, and it was a popular local project to decorate it with seasonally appropriate garb.

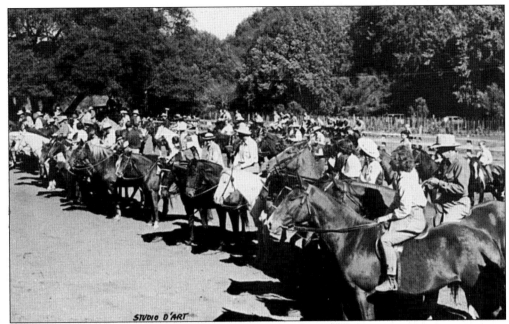

Although they were gradually replaced by cars and tractors for work, horses continued to be important for hobbies and sports. In early years, when most Los Altos streets were unpaved, horses were still ridden around town. Especially in the hills, horse-related organizations grew up. This 1949 photograph shows a horse function at the Duvenecks' Hidden Villa.

The Knapp family is shown at right sorting out their walnuts, grown as one of the crops on their small farm on Santa Rita Avenue (later Los Altos Avenue).

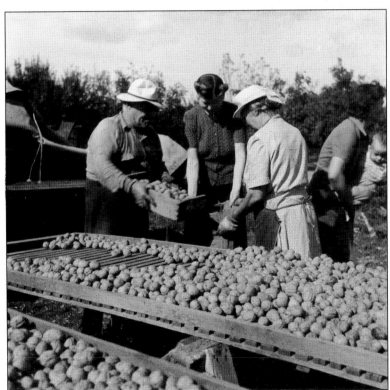

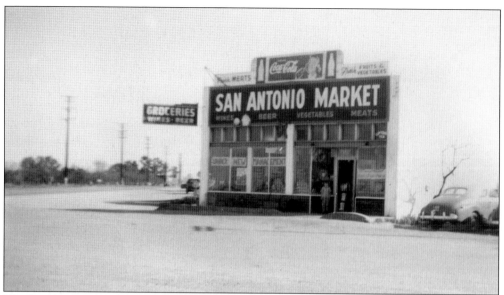

The San Antonio Market picture here was located on the southeast corner of El Camino Real and San Antonio Road. In 1946, its new proprietors, Nate and Aaron Corenman, alluded to their World War II service by advertising, "We've served our country—now we are eager to serve you."

Pilgrim Haven opened in 1949 on Pine Lane, on land that had been continually used for that purpose since 1931, when the Pine Lane Rest Home was established by Margaret Brown. In 1938, it was continued by Evelyn Butler, RN. This photograph shows Pilgrim Haven in its earlier years. It has been improved and enlarged since then.

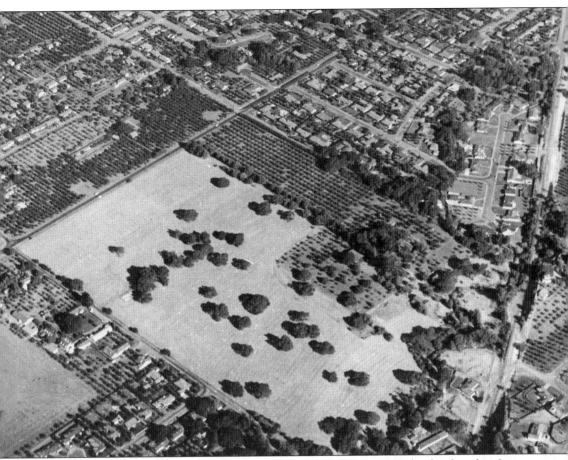

This 1962 aerial photograph show the last sizeable ranch (of 60 acres) to be developed in Los Altos. The view is to the southwest from above Pine Lane, with Adobe Creek and the railroad along the right. When Herbert O. Coloff built it around 1890, its only access from San Antonio Road was a lane named for him. Around 1908, it became Pine Lane, and its eastern boundary became Los Altos Avenue. Isaac Strassburger bought the ranch in 1915, and the family of his granddaughter Maryann (Mrs. Albert Abrahamson) used it until 1962, when it was sold to become the Dos Palos subdivision.

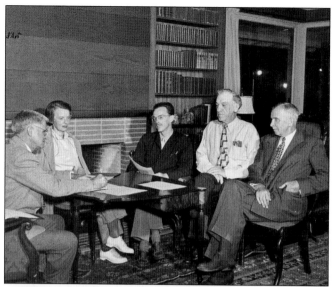

Gardner Bullis (far right) is shown here with the executive committee of the Los Altos Business Association in 1947. Bullis moved to the hills in 1947 and opened his first law office next to Clint's Ice Cream store, later moving to the Rancho Shopping Center. He was uniquely important to both Los Altos and Los Altos Hills, serving both cities as their pro bono attorney when they were first incorporated. He helped save them both when they later had to defeat efforts developed to disincorporate them.

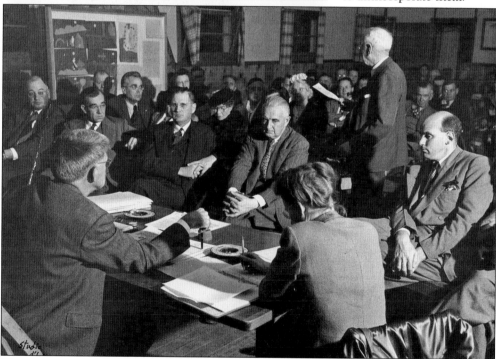

The question of whether or not Los Altos should incorporate dates back at least to 1946. The Los Altos Business Association considered the issue then and was in favor of it, a factor being concern about possible annexation by Palo Alto or Mountain View. Guy Shoup played a leading role when the association was formed in September 1947. It considered the issue again in July 1948, as part of its master plan covering zoning and property use. It formed a Planning Committee to define precise Los Altos boundaries and publicized their views in a *Los Altos News* story headlined "Should Los Altos Incorporate?" The actual campaigns for incorporation engendered strong opposition, delaying the election for Los Altos until 1952. Los Altos Hills decided to go its own way as a more rural community and was incorporated in 1956.

INDEX

About the Los Altos History Museum

Located in one of the few remaining apricot orchards of Santa Clara Valley, the Los Altos History Museum explores the rich history of local people and how the use of the land over time has transformed the agricultural paradise once known as the "Valley of Heart's Delight" into the high technology hub of today's Silicon Valley.

Opened in spring of 2001, the Los Altos History Museum resides in an impressive three-level, 8,200-square-foot building—built entirely with private donations; building ownership was transferred to the City of Los Altos in 2002. The museum features a changing exhibits gallery as well as the permanent exhibit Crown of the Peninsula, which describes the rich history of Los Altos. There is more history just across the lushly landscaped courtyard in the landmark J. Gilbert Smith House. Built in 1905, and serving as the community's first museum since 1977, the home is nestled under majestic heritage oaks and has been meticulously refurbished to replicate a farmhouse of the Depression era. Visitors are welcome to enjoy the gardens and picnic tables even when the house and museum are closed.

With the mission to "collect, preserve and interpret the history of the Los Altos area," the museum provides educational opportunities for children and adults to learn about the community via interactive exhibits and hands-on activities aligned with museum objectives. Other programs include third- and fourth-grade tours and curriculum for local schoolchildren, oral history collections, the traveling Ohlone kit, and much more. Learn more at www.losaltoshistory.org.

www.arcadiapublishing.com

Discover books about the town where you grew up, the cities where your friends and families live, the town where your parents met, or even that retirement spot you've been dreaming about. Our Web site provides history lovers with exclusive deals, advanced notification about new titles, e-mail alerts of author events, and much more.

MADE IN THE USA

Arcadia Publishing, the leading local history publisher in the United States, is committed to making history accessible and meaningful through publishing books that celebrate and preserve the heritage of America's people and places. Consistent with our mission to preserve history on a local level, this book was printed in South Carolina on American-made paper and manufactured entirely in the United States.

This book carries the accredited Forest Stewardship Council (FSC) label and is printed on 100 percent FSC-certified paper. Products carrying the FSC label are independently certified to assure consumers that they come from forests that are managed to meet the social, economic, and ecological needs of present and future generations.

FSC
Mixed Sources
Product group from well-managed forests and other controlled sources

Cert no. SW-COC-001530
www.fsc.org
© 1996 Forest Stewardship Council

Find Your Place in History.